CARTOON COOL

How to Draw New Retro-Style Characters

CHRISTOPHER HART

Watson-Guptill Publications/New York

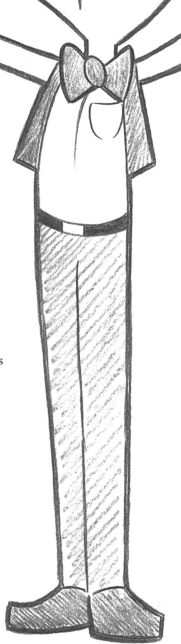

Published in 2005 by Watson-Guptill Publications
a division of VNU Business Media, Inc.
770 Broadway
New York, NY 10003
www.wgpub.com

Executive Editor: Candace Raney
Senior Development Editor: Alisa Palazzo
Designer: Bob Fillie, Graphiti Design, Inc.
Senior Production Manager: Ellen Greene

Inks over pencil: Rich Faber
(pages 99, 103, 105, 106, 107, 109, and 110)

Library of Congress Cataloging-in-Publication Data
Hart, Christopher.
　Cartoon cool: how to draw the new retro characters
of today's cartoons / Christopher Hart.
　　　p. cm.
　Includes bibliographical references and index.
　ISBN 0-8230-0587-9 (pbk. : alk. paper)
　1. Cartooning–Technique. I. Title.
　NC1764.H34 2005
　741.5–dc22

　　　　　　　　　　2004024844

Printed in USA

2 3 4 5 6 7 8 9 / 13 12 11 10 09 08 07 06 05

Contents

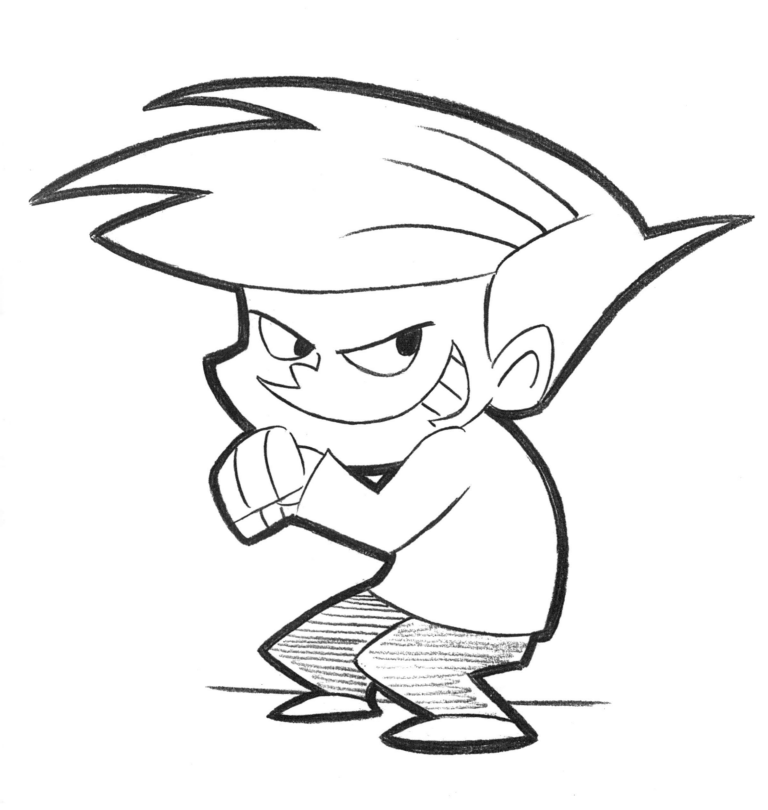

INTRODUCTION: LET'S GO Retro!

It's everywhere you look, in animated television shows and comic books. It's the new retro style. What is *retro*? It's the biggest thing to come along in cartooning in decades. It's a style of illustration loosely based on the animated TV shows of the late 1950s and early 1960s—a time when everything had a flat, graphic look, and the sly humor didn't play down to children.

Retro is also based on character types—character types influenced by the popular family sitcoms of the early to mid-'60s, when everything looked nice on the surface: brownies and milk, moms in the kitchen, and fathers who never yelled. Yet there was always lurking a sense that these families were too good to be true and were repressing some truly bizarre personalities and behaviors. Add a modern look, bring those bizarre personalities to the surface, ratchet up the pace to a fever pitch, and you've got retro. As a cartoonist, you owe it to yourself to stay current and learn how to draw this growing, popular new style.

Interestingly, some of the retro-style drawing principles are the exact opposite of the principles used for drawing traditional cartoons. For example, retro-style action poses are drawn so that the figures seem to conserve energy rather than expend it (which would be the look of a more traditional cartoon).

Retro characters are so nerdy they're cool. The retro style is, in fact, the coolest style of cartooning on the planet. Retro-style animated TV shows have completely stolen the thunder of hand-drawn, animated feature films. While the popularity of the hand-drawn, realistic style of animated movies has waned, retro cartoons are proliferating all over television. And even the most heroic comic book characters and bad guys have been redrawn by publishers and studios into modern, retro versions. But retro is about more than just style; it's also about laughs. It's truly wacky stuff. The characters are quirky, perky, and just a little bit warped. Their break-neck pacing and hysterical characters are generating legions of fans of all ages.

This book is packed to the brim with easy-to-follow, step-by-step instructions and loads of special hints. Anyone, at any level, can benefit and can improve his or her skills by using this book. You'll be shown how to create retro-style heads and bodies from basic shapes, making it easy and fun. You'll learn how to create the basic cast of characters that make up the bizarre retro family unit, including retro pets. You'll learn how to caricature action poses in the unique, retro style, with examples that compare the new way to the traditional way of cartooning. Retro facial expressions and body language are illustrated clearly and in detail. And at the end of the book, you'll be guided through an exciting section on how to draw scenes with multiple characters. Are you ready? Let's go retro!

RETRO Basics

Believe in drawing the fun stuff right out of the box. So, we're going to begin with the basic retro head. As you go along, there'll be lots of special hints throughout the book to help you understand the principles of character design and to provide you with options for creating variations on a theme.

THE RETRO HEAD

Simple shapes are the key to creating today's "new retro" look, and there's no shape simpler than a circle. It's perfectly symmetrical and has no sides. But pay close attention—I'm definitely *not* talking about the old-fashioned, start-with-a-circle approach to cartooning. I'm talking about a self-consciously round cartoon, in which the shape of the circle is not just the starting point but *the whole point*. To emphasize the circle further in the front view, don't open up the circle at the chin as it crosses the neck; keep it a closed loop.

FRONT VIEW

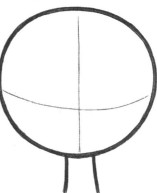

Draw a thin neck that's so skinny it would never really support the weight of that head. Exaggeration is the key to cartoon humor.

Tilt the eyes, in tandem, to one side. This is a cartoonist's trick that adds more zing to the character. Big irises (the colored parts of the eyes) are the favored look in Retroland. The nose is tiny and petite, letting the oversized eyes dominate by way of contrast. And, the lips are full and curvy—a caricature of female lips. The hairstyle should never be carefree or natural looking in retro cartoons. Instead, it should look stiff, not soft.

Now draw small, dark pupils inside the irises. The eyelashes should look like little spikes that could kill (which makes them funny). And you can add striations to the interior of the hairstyle, to give it more flair.

PROFILE

The oval is also a popular shape for retro characters. Notice that the oval shape is the dominant feature of this figure.

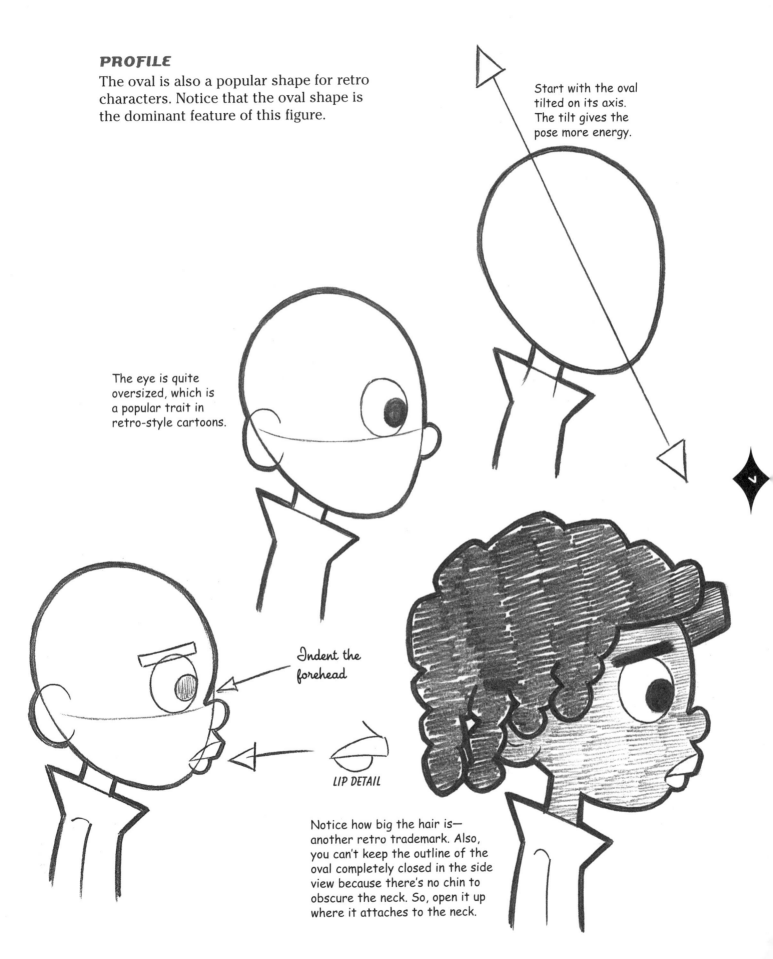

Start with the oval tilted on its axis. The tilt gives the pose more energy.

The eye is quite oversized, which is a popular trait in retro-style cartoons.

Indent the forehead

LIP DETAIL

Notice how big the hair is—another retro trademark. Also, you can't keep the outline of the oval completely closed in the side view because there's no chin to obscure the neck. So, open it up where it attaches to the neck.

3/4 VIEW (FACING VIEWER'S LEFT)

Now let's modify the basic shape a bit more so that it's somewhere between an egg shape and an upside-down teardrop shape. This is a common shape for teenagers of about 14 years of age. The face is still round but shows signs of elongation, especially in the jaw and chin. Yet the face is somewhat soft, as shown by its rounded sides.

Start with the basic shape. Note that boys' necks get thicker as they grow.

Sketch in guidelines.

Keep the features simple, big, and clear, with no subtlety. Eliminate all facial creases—you don't need them, and they take away from the clean look of the character. The ears stick out conspicuously on retro characters so that they're funny looking! (Only one ear shows in this angle, though.)

Add the hair, and thicken the eyebrows.

Retro cartoons are based more on design principles and less on drawing principles. It's like fitting together cool parts to create a snappy character. Sometimes artists try to do too much with their drawings. Do less, not more. Concentrate on the overall shapes, not on the interior features.

3/4 VIEW (FACING VIEWER'S RIGHT)

Here's another character with a crystal-clear shape for her head. Not even her chin, cheek, or hairline creates so much as a bump in the outline of the head, which is a simple oval. It's a very pleasing look. The eye is drawn to simple shapes.

MORE HEAD SHAPES

Any basic shape can be turned into a retro-type cartoon character. Give these three a try.

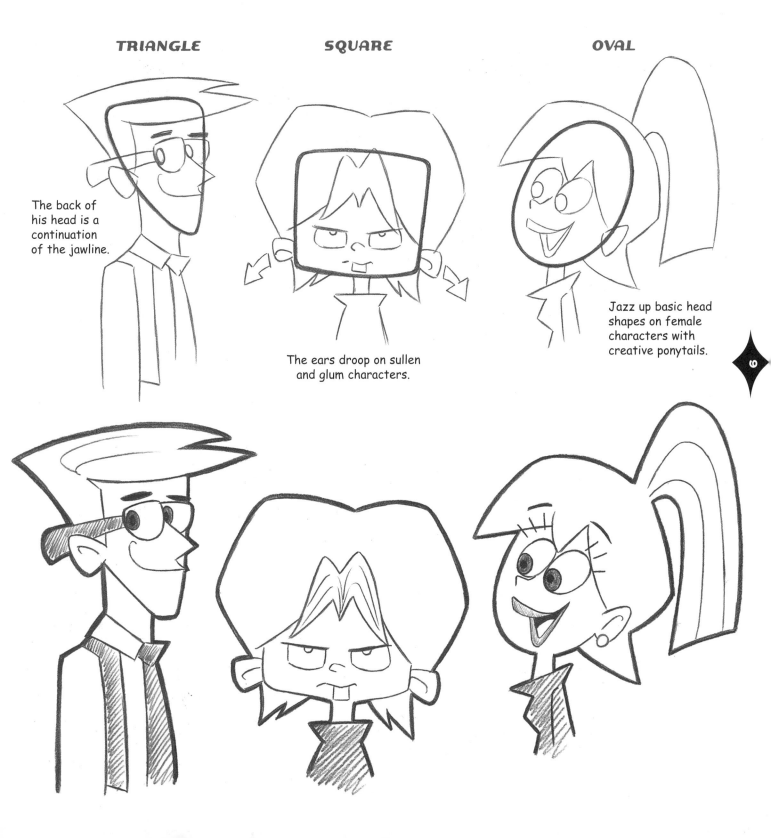

TRIANGLE

The back of his head is a continuation of the jawline.

SQUARE

The ears droop on sullen and glum characters.

OVAL

Jazz up basic head shapes on female characters with creative ponytails.

ENLARGING THE UPPER JAW

To make your character stand out more, try this effective technique: enlarge the top of the mouth or upper jaw (the maxilla), and leave the lower jaw (the mandible) unchanged. This will immediately add a goofy look to any character.

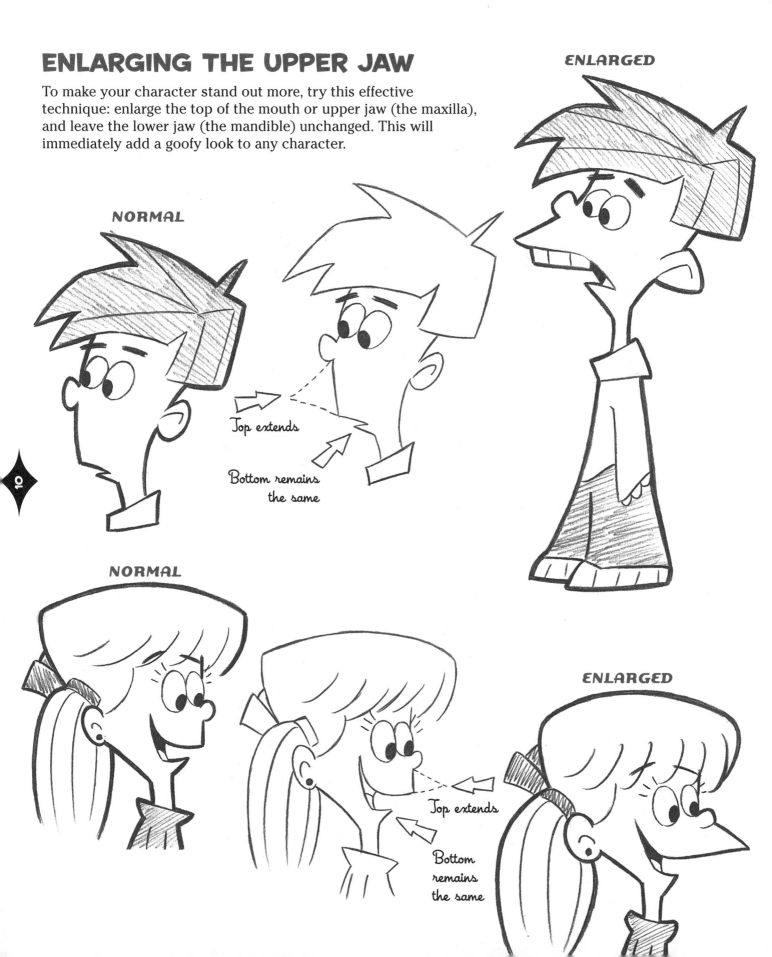

ENLARGED

NORMAL

Top extends

Bottom remains the same

NORMAL

ENLARGED

Top extends

Bottom remains the same

TRADITIONAL "ROUND" LOOK

Shoulders slope amiably

Forehead curves in

Cheek protrudes

Lower lip shows thickness

Tummy sticks out in a cute way

DRAWING THE FLAT BODY

A bold, simple, and clear outline is all-important in creating a flat look. To create a flat character, the outline of the head and body should be emphasized so that the overall shape is unmistakable. Make the outline thick and make the lines for the details inside the main outline thin. That's the general rule, although you can break it when, for example, one part of the body overlaps another.

Main pencil line is quite thick

DRAWING "FLAT" CHARACTERS

The key to drawing retro characters is to make them look flat. This probably goes against everything you've learned about how to draw, when the whole point is to make things look real and three-dimensional. But the flat look is indispensable for drawing this new retro style. Here are some important tips to keep in mind.

RETRO "FLAT" LOOK

Hair has striations in it

Eyebrows are thick and are visible through hair (as if sitting on top of it)

Ears stick out

Back is straight (for a stiff and flat look)

Front of head is a single, unchanging curve

11

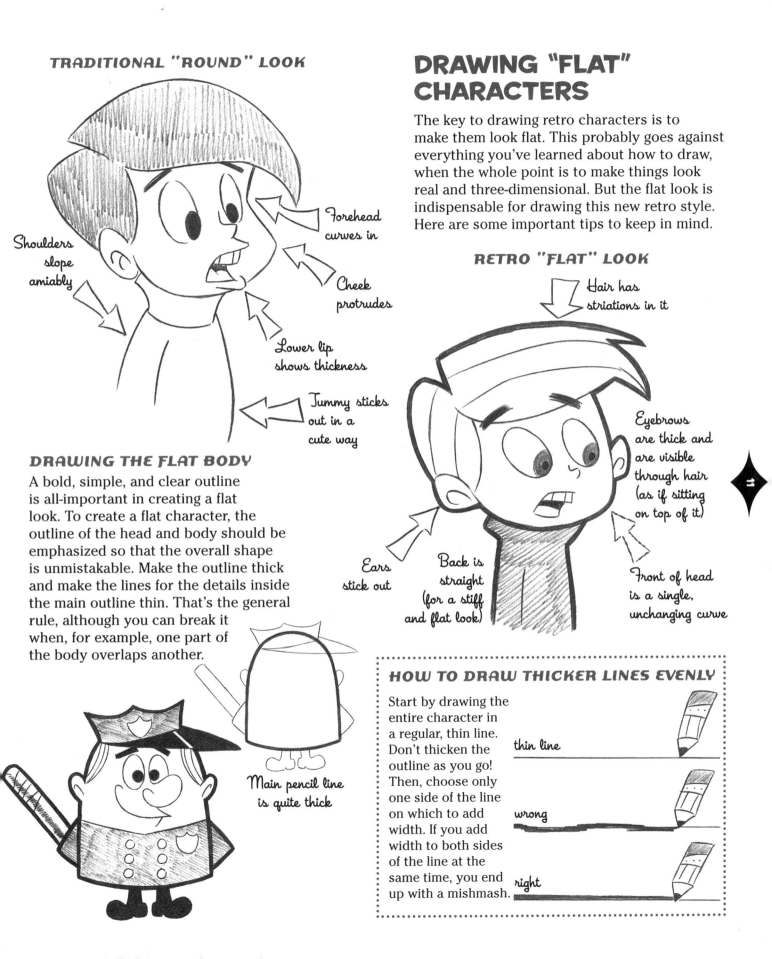

EYES

Since the eyes are the most expressive feature of the face, matching the correct eye style to the character type is essential. Whenever I begin to draw the features of the face, I start with the eyes. If they don't come out just right, I erase them and start over. I just can't get the feeling of the character, and go on to create the expression and posture, unless the eyes are working for me first.

There's no wasted effort in drawing eyes! (And certainly no waste in designing and drawing them first.) All of your efforts will pay dividends.

FEMALE

Style, and lots of it, is the name of the game in drawing retro cartoons. And that's especially important for female eyes.

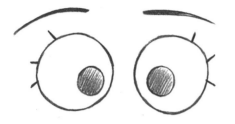

This is a classic. Circular eyes with attached eyelashes and large pupils. Very popular, very funny, especially for cartoon moms.

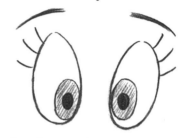

Here's another favorite for cartoon moms that can also be used effectively for perky teenage girls. The eyelashes curve upward. The eyes are vertical elongated ovals. Note the use of a two-toned iris and pupil area here.

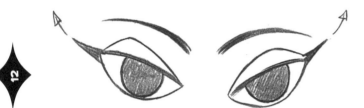

These are for attractive female characters only. The half-closed eyelids always indicate an alluring character. The top eyelid is always drawn darker. The eyelashes are bunched into a single, thick lash that sweeps up at the end.

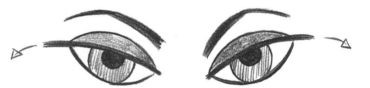

This eye type can be used on an attractive character, a mysterious character, or a sinister character equally well. The eyelids are shaded to indicate eye shadow. The eyeballs have pupils, and the eyelashes curve down. (Note the thick eyebrows.)

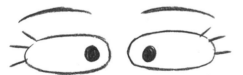

These kooky eyes are shaped like rounded rectangles. For an even more stylized look, place the pupils in the center of the eyeballs, instead of close together. It will give your character a weird, vacant stare.

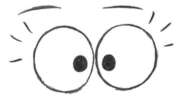

Another appealing, goofy look. The eyes press together, the pupils are small, and the eyelashes "float." (See page 74 for more on floating.)

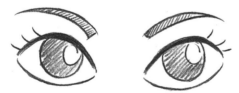

She's the girl next door. Innocent characters have big eyes with big shines in them. The overall form of the eye is almond-shaped. To make her sexier, tilt the eyes up slightly at the ends.

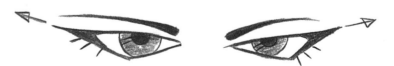

Pretty severe, eh? She's evil, you betcha. Apply that eyeliner like shellac.

MALE

For male characters, too, there's a wide variety of eye types from which to choose. Although male characters don't have eyelashes with which to play, their eyebrows are far more varied than those on female characters.

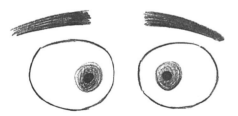

This is the classic retro look, good for almost any male character: round eyes, with medium-size pupils (and no irises).

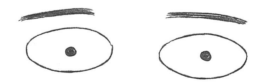

An appealing, quirky look. The eyes are oval and spaced apart, with small pupils floating in the middle and thin eyebrows.

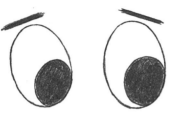

A good type for boys ages 8 to 12. Huge pupils dominate the eyes. The eyebrows are small.

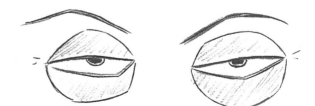

The eyes stand up, vertically, with small pupils. Good for worried and high-energy grown-ups.

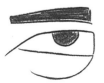

This is the overworked dad type. Note how the eyelids slope down at the ends. Bags form under the eyes, and the eyebrows are thick and angular. This is how you will look at 40. Trust me.

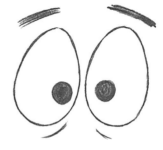

Isn't this one a riot? He's either a mad professor or an evil scientist. Heavy eyelids and bags under the eyes, with only slits for him to see through. Tiny beady eyes peer out at us. The eyebrows are thin, crooked, and delicate.

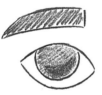

Almond-shaped eyes always indicate innocence and lack of guile on boys. The pupils must be large, which is also a sign of honesty in a character.

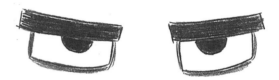

Intense and mean characters (drill sergeants, phys-ed coaches, and the like) often sport heavy eyebrows that sit right on top of the pupils. Add a little touch of shading under the eyes to add intensity.

LIPS

Here's where a lot of beginners—as well as experienced cartoonists—lose their way and end up with less attractive characters than they had hoped for. Men's lips are so simple that they don't even require separate examples here. You'll learn to draw them easily just by following the steps for the male characters in this book. It's women's lips that you need to pay special attention to.

Actually, attractive, women's lips are some of the easier things to draw—if you know which type of lips you're drawing. The problem is that many cartoonists don't decide on the lip type and end up with an uncomfortable amalgam of realistic lips and cartoony lips. Toss out the realistic version. Instead, make them highly stylized, which simplifies them and makes them much more fun.

FRONT VIEW SIDE VIEW

This is the classic overbite. It's attractive, some would even say sexy, for the upper lip to be longer than the bottom one. The indentation in the center of the upper lip, resulting in a Cupid's bow shape, is simple and doesn't require any subtlety; it can be used to make a character more voluptuous.

FRONT VIEW SIDE VIEW

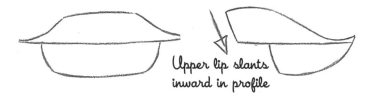

Upper lip slants inward in profile

Here's the overbite without the Cupid's bow shape. Generally speaking, the more attractive the character, the bigger the upper lip.

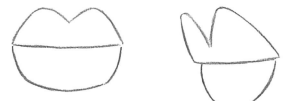

This is a good type for pouty cartoon characters. Both the upper and bottom lips are of even length, but they're short widthwise and tall heightwise.

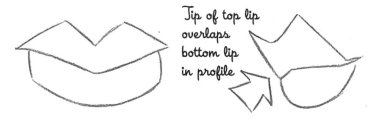

Tip of top lip overlaps bottom lip in profile

The dipping lip is usually used for attractive female characters. It's the same as the first lip style, except that the middle of the upper lip dips down and the bottom lip widens slightly to accommodate this.

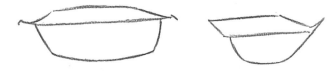

The big bottom lip isn't that commonly used but can be effective in creating a unique character.

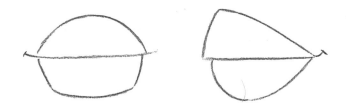

These are the simplest lips you can draw. They work well, and they're funny. No Cupid's bow shape, not much of an overbite. Give it a try.

FACIAL EXPRESSIONS

The solid shape of the face—its outline—is so important on retro cartoon characters that it doesn't squash or stretch to fit a particular expression the way it would in a traditionally drawn cartoon. Most of the action occurs in the eyes and the elastic mouth. Here's a sampling of the most popular expressions you'll need to know. Note how the basic outline or shape of the head remains unchanged from expression to expression.

CONFIDENT

One eyebrow goes up, the other down, and both eyes are half closed. This is a much more sophisticated expression than one would expect to find on a boy of this character's age. But that's what makes it funny.

UPSET

The eyeballs must be cut off by the eyebrows. The mouth is small and taut.

UPSET EYE VARIATION

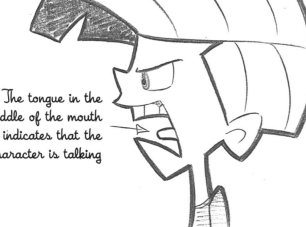

The tongue in the middle of the mouth indicates that the character is talking

ANGRY

Teeth usually show when a character is angry.

READY TO EAT

Bright eyes, tongue firmly pasted on upper lip. Yum!

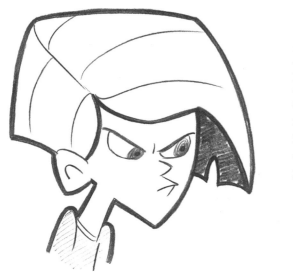

CONCERNED

Note the body language. Instead of eyebrows, use big folds of eyebrow muscles to curl up over the eyes. The mouth gets small.

CONCERNED MOUTH VARIATION

BROODING/ SCHEMING

Scrunch all of the features together in the middle of the face. The eyes crush down and the mouth pushes up.

SURPRISED

A surprised expression is displayed by showing large, round eyes with tiny pupils. The pupils can actually change size to fit the expression.

BIGGER SURPRISED LOOK

SUPERIOR

Closed eyes show confidence. Combine them with a big grin and you've got a know-it-all.

SHEEPISH

I love this one. Showing the lower eyelids in an expression was very popular in 1930s cartoons but went by the wayside until recently. Now this technique is used all over the place. Note that the grin must rise way up into the cheeks.

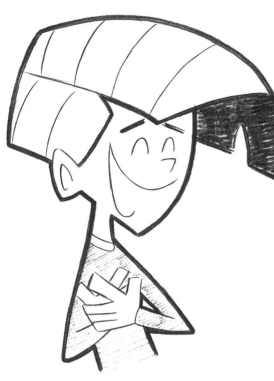

AFFABLE

The affable smile is just a big grin with the eyebrows raised high. It helps if you can position the pupils in a corner of the eyes, as this makes the expression sharper. Even on a breezy, pleasant expression like this, it's good to exaggerate something, which in this case is the curl of the grin.

LAUGHING

Take the eyes from the Superior expression on the previous page, flip 'em over, and you've got the eyes for a laughing character. The mouth opens wide, but you don't necessarily have to show teeth or a tongue.

WICKED

Combine a scrunched smile with evil eyes for an effective look.

UH OH!

All young characters need to have this look in their repertoire of expressions. God knows I looked like this enough when I was growing up! Tilt the head down. The pose won't be effective unless the head is bowed. The character needs to be looking up from the corner of the eyes. Keep the mouth tiny. This expression is often followed by the Sheepish one on the previous page.

SYMPATHETIC

Sympathy is an important emotion to give characters. It humanizes them. Combine a smile with worried eyes for a look of sympathy.

RETRO BODIES

Just like the head shape, the retro body—especially the torso—must be based on a simple and clear shape. Don't soften the edges to make it subtler. That's a fine approach for traditional cartoons, but it won't give you that retro look.

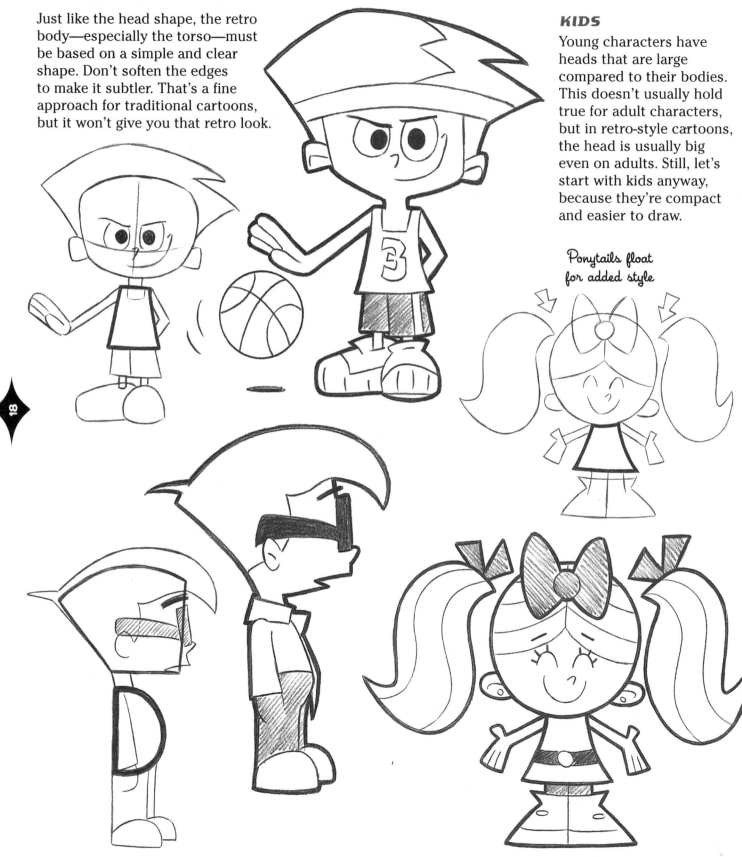

KIDS

Young characters have heads that are large compared to their bodies. This doesn't usually hold true for adult characters, but in retro-style cartoons, the head is usually big even on adults. Still, let's start with kids anyway, because they're compact and easier to draw.

Ponytails float for added style

TEEN

Since we're concentrating on creating a single, basic shape for the body, the outline of the dress itself will become the shape of the body. In retro cartoons, you don't want to see the stress marks that result from the body tugging on the fabric. There are no creases or folds to complicate the drawing, which must remain simple and slick in order to be pleasing to the eye.

Note the absolutely flat tops of the ponytails. This could never happen in reality, but again, we're trying to emphasize shapes. There are only two ways to do this: either flatten things out or make them round. Combining flat shapes (the tops of the ponytails) with round shapes (the top of her head) adds a lively contrast.

EVIL ADULT

The lab coat is a classic for evil characters. Note the excessively long body, combined with a big head. This tells the audience that the character relies on brainpower, not brawn. The bow tie, which is tight enough to strangle this guy, indicates that he's tightly wound and barely able to maintain a socially acceptable demeanor in public.

In traditional cartooning, you'd first outline the body, sketching in the legs as they wedge into the hip joints, and then you'd draw the lab coat over it. But that would be a mistake here. Here, the legs are *meant* to look pasted onto the bottom of the coat. The fact that there isn't a single hint or indication of the underlying body structure is what gives this cartoon its sought-after flat look.

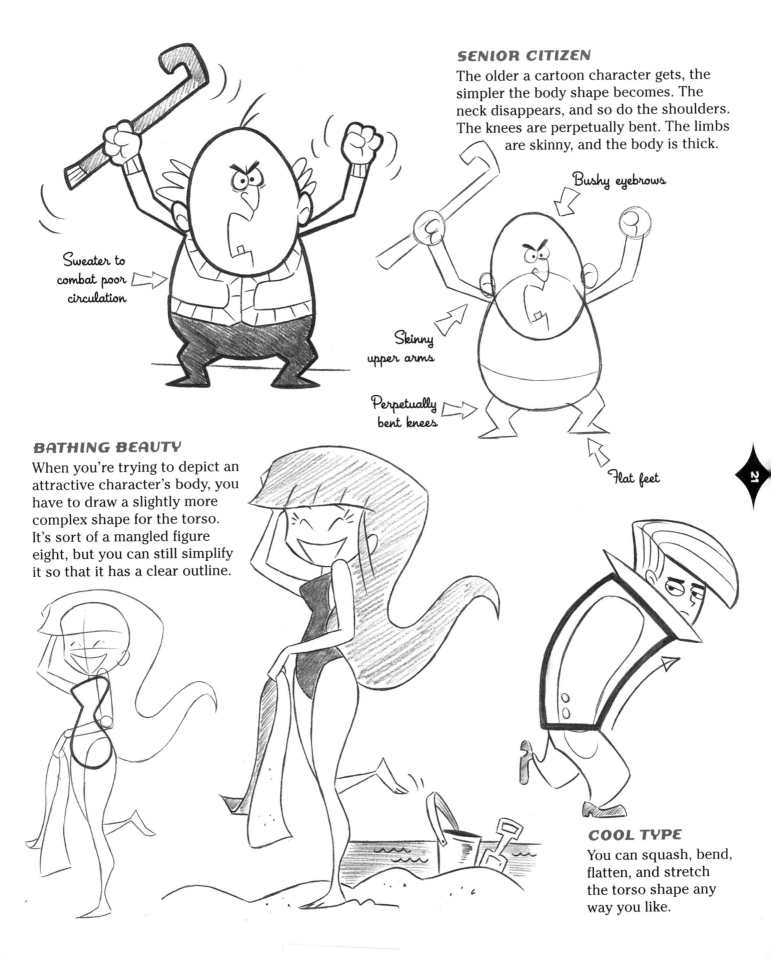

SENIOR CITIZEN

The older a cartoon character gets, the simpler the body shape becomes. The neck disappears, and so do the shoulders. The knees are perpetually bent. The limbs are skinny, and the body is thick.

Bushy eyebrows

Sweater to combat poor circulation

Skinny upper arms

Perpetually bent knees

Flat feet

BATHING BEAUTY

When you're trying to depict an attractive character's body, you have to draw a slightly more complex shape for the torso. It's sort of a mangled figure eight, but you can still simplify it so that it has a clear outline.

COOL TYPE

You can squash, bend, flatten, and stretch the torso shape any way you like.

PROPORTIONS

The common method of coming up with the proportions of a character is to "stack heads." The standard approach has always been: the younger the character, the fewer heads tall; the more mature the character, the more heads tall. But with retro cartoons, this isn't necessarily so. This retro-style Kewpie-doll bombshell is only three heads tall, whereas most traditional adult cartoon characters are four to six heads tall.

1/3 1/3 1/3

The body is a third of the width of the head. This is what gives this figure her diminutive, cute look.

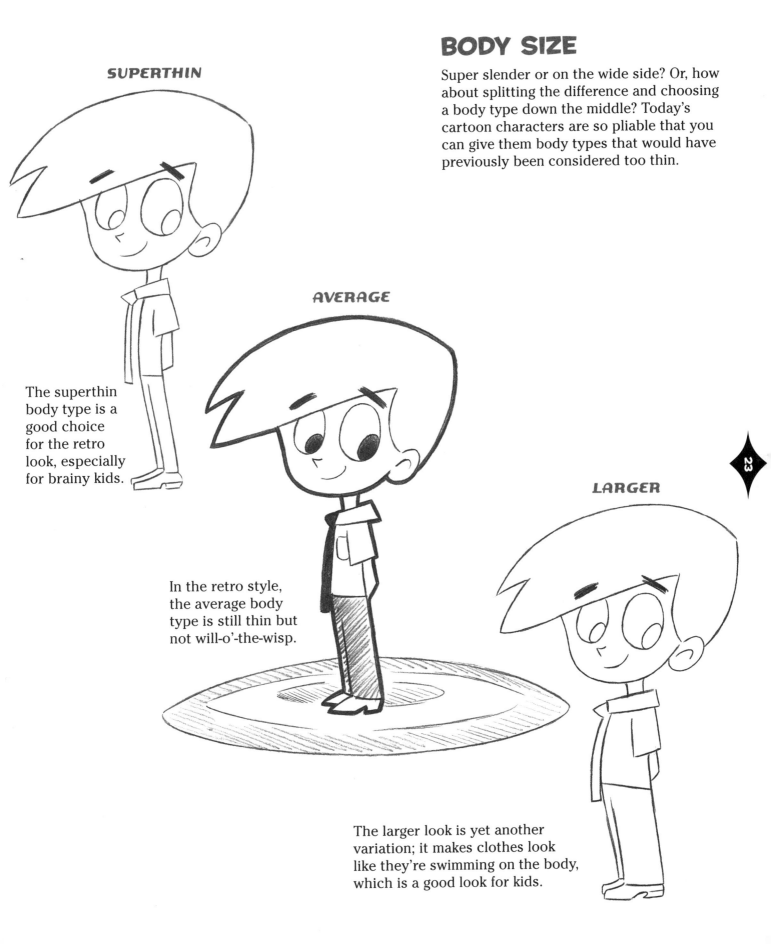

SUPERTHIN

BODY SIZE

Super slender or on the wide side? Or, how about splitting the difference and choosing a body type down the middle? Today's cartoon characters are so pliable that you can give them body types that would have previously been considered too thin.

The superthin body type is a good choice for the retro look, especially for brainy kids.

AVERAGE

In the retro style, the average body type is still thin but not will-o'-the-wisp.

LARGER

The larger look is yet another variation; it makes clothes look like they're swimming on the body, which is a good look for kids.

THE IDEALIZED CARTOON FIGURE: TRADITIONAL VS. RETRO

Many characters—especially teenagers, heroes, and action characters—possess idealized cartoon versions of the human body. And many of those characters wear tight clothing that reveals their form. So, they can't have a body that looks like an oval, because whose ideal would that be? Still, to be retro, the body has to be based on bold, simple shapes. Compare the figures below and opposite to see how to create an anatomically viable idealized model for retro-style cartoon purposes.

TRADITIONAL

This is a perfectly good drawing of a cartoon character's muscles and anatomy. But it's no good for retro cartoons because it goes against the basic retro tenet: simplify, simplify, simplify!

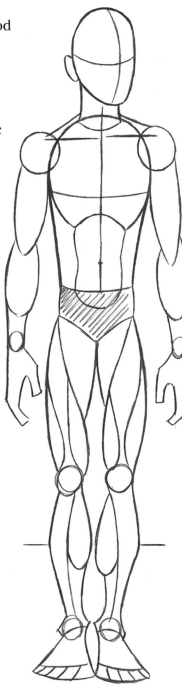

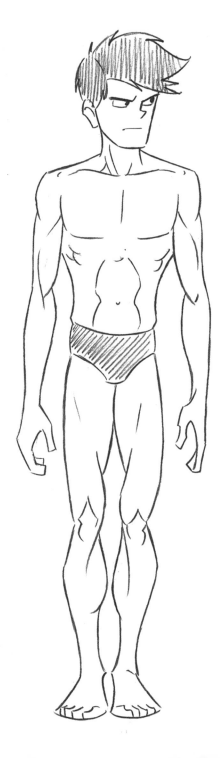

RETRO

Instead of focusing on individual muscle groups, as in the traditional example opposite, concentrate on the overall shape of the body. Focusing on the overall shape is much more important than knowing where the rectus femoris (middle thigh muscle) begins and ends. The legs are highly exaggerated in stylized cartoons of this sort. Notice that developed thigh muscles are suggested exclusively by the curved outline; no interior muscle definition is necessary. And the calves, which are the most exaggerated body part of all, curve outward severely. It's important to draw them with "muscle peaks," otherwise the character will look bowlegged. Note the simplicity of the chest muscles and also how the elbow joints make the arms wider in the middle.

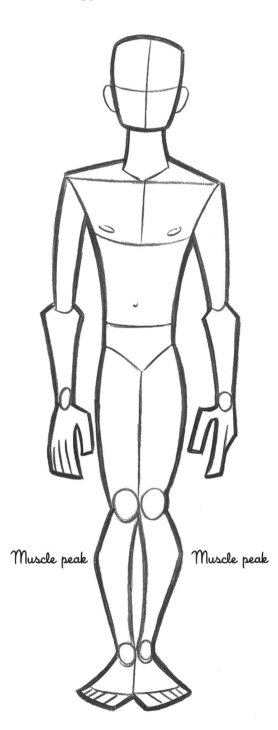

Muscle peak Muscle peak

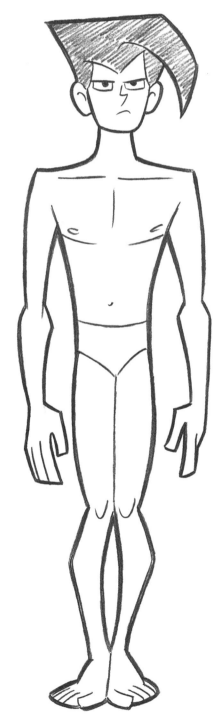

THE NECK AND SHOULDERS

This is where things can get tricky—but they don't have to!
Don't think of the neck and shoulders as two separate areas.
They're fused together to create one section of the body—
the neck/shoulder region—and it helps to think of them
that way. Whether the shoulders slump or are held squarely
has a huge effect on a character's posture and, hence, his
or her personality. *Note*: Female characters can have more
variations of the neck/shoulder region than male characters.

BASIC ANATOMY

The collarbones (A) act like a shelf,
giving the top of the chest its square
look. The main neck muscle (B) (the
sternocleidomastoideus for all
you guys who simply have
to know what to call it)
appears on each side
of the neck and travels
from the bottom of the ear
to the pit of the neck—and it's
accentuated in many poses.

FEMALE VARIATIONS

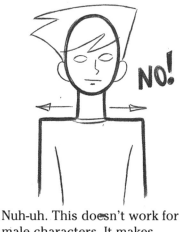

SLOPING
This can be an attractive
look, especially with
outfits that reveal
bare shoulders.

SQUARE
You probably think that
men have square shoulders
but that women's shoulders
should be given a softer
treatment. Oh, how
wrong you are, my friend.
Square shoulders are a
very attractive look for
any female character.
Emphasizing the width
of the shoulders is
attractive. Burn this
into that cartoonist's
brain of yours.

SLIGHT CURVE UP
This is a highly stylized
version in which the
shoulders are actually
pointed up. It's a sharp,
effective look for
bombshell characters.

MALE VARIATIONS

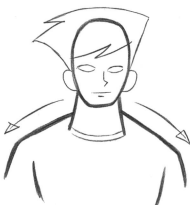

ROUNDED
Rounded shoulders that begin
above the base of the neck can
make a guy seem very powerful.

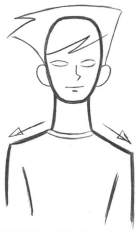

FLAT WITH A SLIGHT SLOPE
This is the typical approach
to drawing male shoulders.

AVOID STRAIGHT SHOULDERS ON MEN!

NO!

Nuh-uh. This doesn't work for
male characters. It makes
them look tense and unnatural.

BUILDING THE BODY SECTION BY SECTION

Teenagers, some adults, and action characters often need more than a single shape for the body—but not much more. The torso is still a rectangle, which can be pulled and stretched into many variations.

But you also need to add a neck/shoulder section, as well as a simple hip section. Assembling the parts as blocks, at least until you get used to the process, makes the figure much easier to draw.

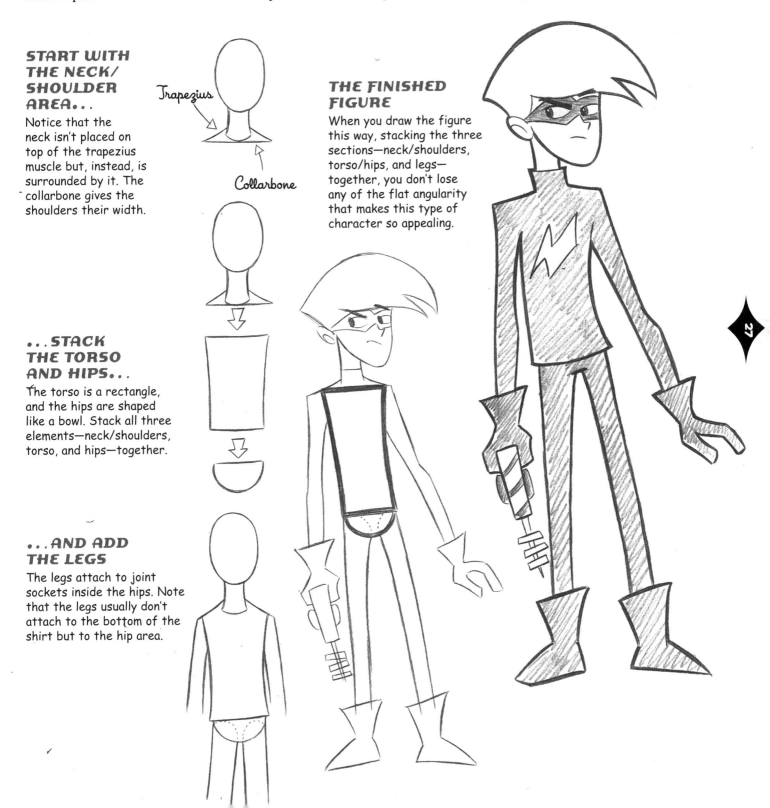

START WITH THE NECK/ SHOULDER AREA...

Notice that the neck isn't placed on top of the trapezius muscle but, instead, is surrounded by it. The collarbone gives the shoulders their width.

Trapezius

Collarbone

THE FINISHED FIGURE

When you draw the figure this way, stacking the three sections—neck/shoulders, torso/hips, and legs—together, you don't lose any of the flat angularity that makes this type of character so appealing.

...STACK THE TORSO AND HIPS...

The torso is a rectangle, and the hips are shaped like a bowl. Stack all three elements—neck/shoulders, torso, and hips—together.

...AND ADD THE LEGS

The legs attach to joint sockets inside the hips. Note that the legs usually don't attach to the bottom of the shirt but to the hip area.

"MOLDING" THE TORSO

You can mold the rectangular torso shape, twisting, stretching, and bending it like a piece of a clay. But keep the shape simple, with no muscle definition. In this picture the trapezius muscle in the shoulders has been eliminated from view. If it were built up, it would make the character look too husky.

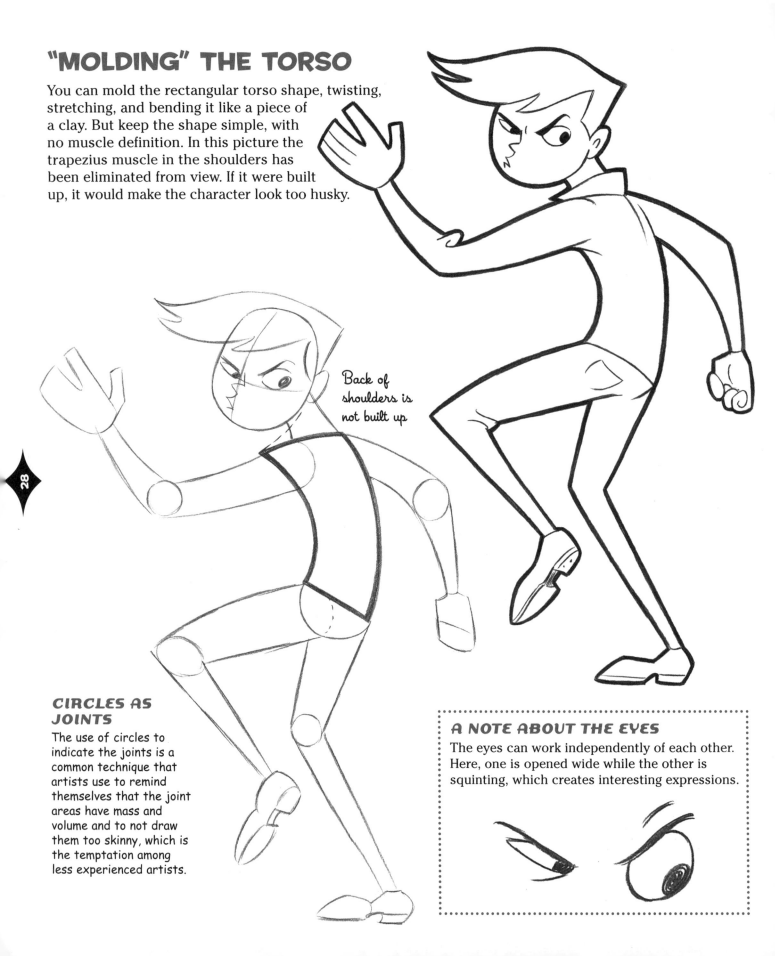

Back of shoulders is not built up

CIRCLES AS JOINTS

The use of circles to indicate the joints is a common technique that artists use to remind themselves that the joint areas have mass and volume and to not draw them too skinny, which is the temptation among less experienced artists.

A NOTE ABOUT THE EYES

The eyes can work independently of each other. Here, one is opened wide while the other is squinting, which creates interesting expressions.

THE FEMALE TORSO

The adult female body is a more complicated piece of work than the adult male figure, due to the shape of the torso. It's not just because of all the curves, but because of the contrast of the wide shoulders, thin waist, and wide hips—all in a relatively small amount of space. However, after you get this part down, everything will fall easily into place.

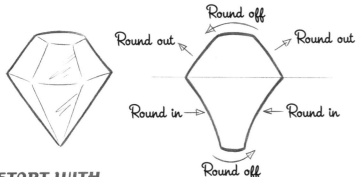

Round off

Round out Round out

Round in → ← Round in

Round off

START WITH A DIAMOND-SHAPED TORSO...

The female torso is basically a very simplified, rounded diamond, so start with a simple diamond shape.

...AND ROUND OFF THE DIAMOND

The first thing to do is shave off the bottom tip of the diamond to create a surface that fits into the hips. Then it's simply a process of rounding off the outline as labeled above.

THE FINAL TORSO

The final female torso looks like this. It, too, can be stretched, thinned out, or adjusted in any way according to your own taste and inspiration.

ASSEMBLING THE FEMALE FIGURE

Place the modified diamond-shaped torso on top of a squashed oval. The oval represents the hips. Make sure the torso is placed slightly down inside of the hip area (see drawing at right).

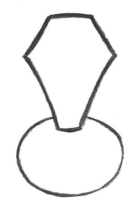

Note that the bottom of the torso shape is quite thin. This is important! There should be no gradual widening from the waist to the hips—it's a sudden shift in shape. That abruptness, that lack of subtlety, is what you're looking for. It gives your cartoons that retro look.

The thighs wedge deeply up inside of the hip area and fill out all the room the hips can give them. This is true not only in cartoons but in real life.

29

THE ATTRACTIVE FEMALE FIGURE STEP BY STEP

Now that you're familiar with how the major sections of the body are assembled, you can put it all together to make a finished figure. With this female character, I've separated the torso from the hips just a bit on the construction drawing to stretch the midsection slightly, because she wears clothing that emphasizes that area. This is just one of the many ways that you can make small adjustments in the construction of a character to tailor it to your needs.

BASIC TORSO/HIP CONSTRUCTION

Above is the basic torso/hip construction. Above left is the adjusted torso/hip construction with the torso separated slightly from the hip to accentuate the midsection.

A NOTE ABOUT DRAWING FLAT

Traditional hair ruffles

Traditional hair ruffles

In a traditional-style cartoon, the ends of ponytails would be carefree and ruffled. For the flat, retro look, slice off the ends of the ponytails with a crisp, clean—and unnatural—line. This adds more style.

MODIFIED SIDE VIEW

Drawing a mature female figure in a side view requires a different approach to the leg treatment. Create the front of the legs with a single smooth line, while using a bumpy line for the back of the legs to indicate the upper thigh and calf muscles.

Thigh muscle curve

Smooth line

Calf muscle

Leave space for the high heels when roughing out the character.

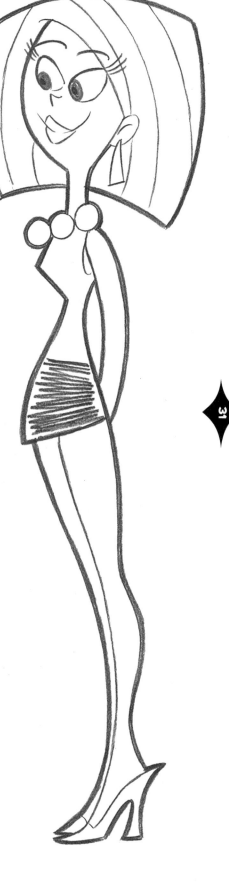

RETRO HANDS

Like people, hands have personalities, and you've got to draw them to reflect their owners! Please follow along, and no talking while the demonstration is in progress. Thank you.

TYPES OF HANDS

KID
Pudgy and short.

TEEN/ADULT
Not too angular or bony.

MIDDLE-AGED ADULT
Bones start to show through at the knuckles.

FEMALE
Slender with thin, tapered fingers. Nails are unnecessary.

← Protruding wrist bone

SENIOR CITIZEN
Palms get wide, fingers curl, and bones protrude. Although the hands are large, they are also skinny.

BASIC HAND DIAGRAM—PALM SIDE

The palm has two basic areas: the heel (A) and the thumb muscle (B). The heel section is longer, but the thumb section is wider. You can draw all the fingers at the same length, or you can vary them. I choose to make all of the fingers the same size, except the pinky, which remains shorter. The thumb has a fat joint at its origin where it sticks out. Don't leave this out of your drawing!

Joint at base of thumb sticks out

BASIC HAND DIAGRAM—BACK

Fingernails are optional, and so are the knuckles.

Joint at base of thumb sticks out

HAND GESTURES

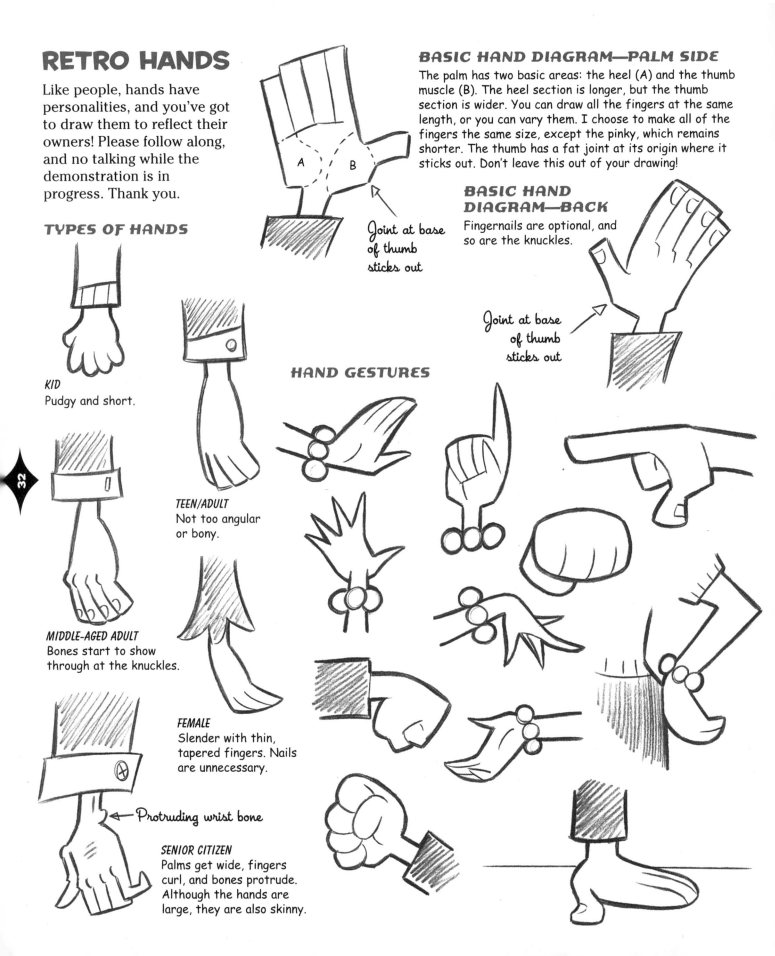

FEET

There's the temptation to rush when drawing the feet because, typically, they're the final thing to be done in a drawing. But why rob your drawing of a finishing touch? Feet are funny! So, put some effort into them. Here are some useful examples.

BARE FEET

In front and 3/4 views, balls of feet show

Side of foot has padding

Main ball of foot appears under big toe

Heel

Ankle bracelet

Pointing big toe up adds a bit of humor

Balls of feet can be seen from underside, too

Wiggling toes are always funny (no one knows why)

RIDICULOUS SHOE STYLES

Fuzzy slippers are a must for middle-class family types!

When drawing feet in high-heeled shoes, first draw the bare foot with the heel raised. Make sure the bridge of the foot descends at a steep angle. Then add the shoe.

FRONT VIEW

WOMEN'S SHOE

TENNIS SNEAKER

FROM ABOVE

WOMEN'S SHOE

TENNIS SNEAKER

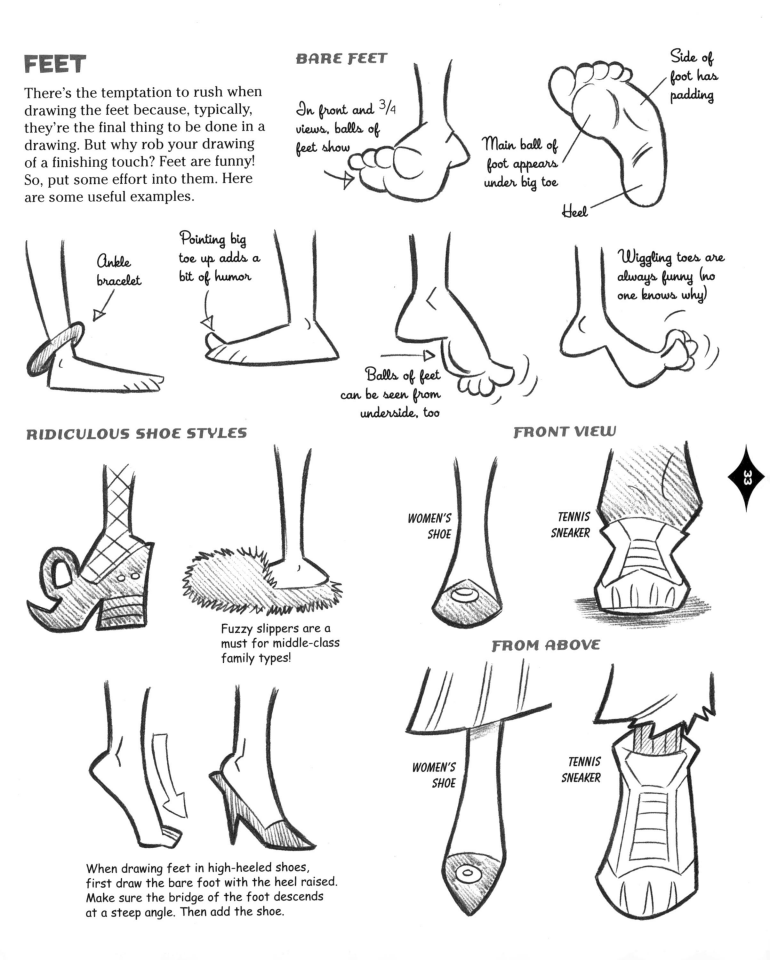

THE RETRO Family

The keystone of so many funny comic strips, animated TV shows, and comics books is the strangely dysfunctional family unit. The retro family is a riot. Think of it as the quintessential 1960s sitcom family—but with each member suffering from Attention Deficit Disorder. Each family member is a turbo-charged nerd, self-centered in the extreme but with a weird patina of sugarcoating. The cast of characters goes as follows: the retro dad and mom, who are always annoyingly enthusiastic—and clueless—about everything; the retro older sister (you know her type: the sadistic babysitter); and her younger retro brother, who is often the most likable, creative, and inventive of the bunch.

THE SUBURBAN DAD

Let's start with the parental units. How about the titular head of the household: the affable but totally obtuse dad. Why do dads always wear shorts with long, black socks? Is there a fashion part of the brain that gets damaged as a result of becoming a father? We may never fully understand the cause of this mysterious ailment. The Hawaiian shirt, off the rack from a "superstore," is also an essential characteristic of the fashion-challenged. The legs are skinny, and the trunk shows a hint of middle-aged paunch. The nose is almost always sharp and angular, and the chin usually juts out.

HOME ON THE RANGE: THE BARBECUE

The suburban retro dad is king of the barbecue grill but almost nothing else. The fun of this body type lies in the contrast of very round lines alternating with straight lines on opposite sides of the same limbs. And as always, dad sports a large chin and embarrassingly long socks worn with shorts. Top-heavy characters are funny because their torsos are much longer than their legs.

Inner leg straight

Outer leg round

Outer arm round

Inner arm straight

A DAD, A BATHROBE, AND A CUP OF COFFEE

Some things just seem to go together. I don't know how many dads actually wear bathrobes and slippers, but retro cartoon dads certainly do. Just as with the dad at the barbecue grill, you need to find the stereotypical props of a modest suburban life in which all is well and shopping from the right catalog brings joy and harmony to the household. The bulky bathrobe makes a nice contrast to dad's skinny calves, wrists, and neck.

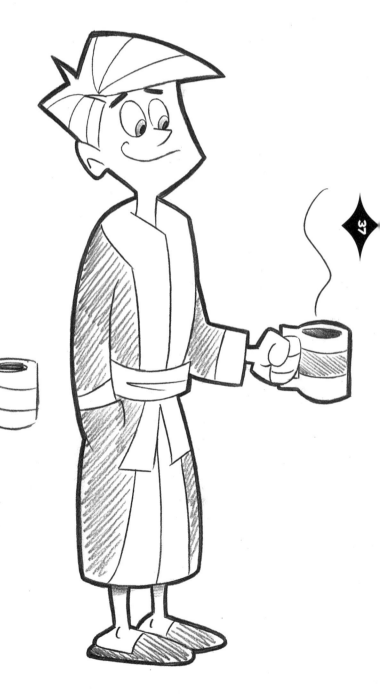

DADS WITH GLASSES

Oversized eyeglasses are a common theme for retro dads but not for retro moms. Glasses make dads look wonderfully geeky; while on moms, glasses can have the opposite effect, making them look stylish—and you don't want that. The frames of the glasses become the outline for the whites of the eyes. All you have to do is draw the pupils or the pupils in the irises.

Open part creates an interesting graphic

Don't draw side of head through glasses

38

MORE DAD SHAPES

ATHLETIC NEW DAD

This new father still has some
of his athletic build intact. Just
give him a few more years!
What makes him funny is that
his trunk is large, while his
arms and legs are so short.

SKINNY DAD

Skinny dads are just the
opposite of athletic dads,
with their legs longer than
their torsos. (Note the
different style of glasses.)

THE PERSISTENCE OF DAD

You can take the dad out of the office but you can't take the office out of the dad. The fun part about these wacky retro characters is that they never change! You can put them in any environment, anywhere, dress them in any type of clothing, and still, it's dad, 24/7.

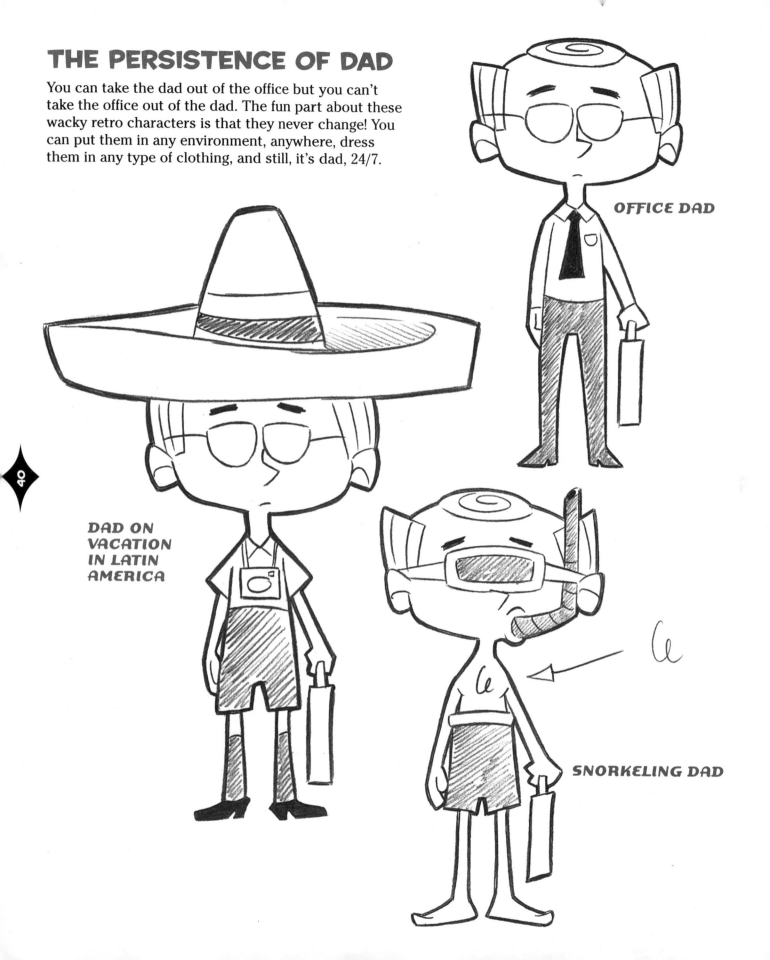

OFFICE DAD

DAD ON VACATION IN LATIN AMERICA

SNORKELING DAD

THE BASIC RETRO MOM

Ah yes, there she is, the happily fulfilled homemaker. She is frequently seen wearing an apron and oven mitts. Her real marriage is to her kitchen. It's every feminist's nightmare—and so lacking in political correctness that it's hysterical. Nonetheless, you can be sure of one thing: her linoleum floors are always clean and shiny!

This character's head, which is loaded with expression, is always large compared to her body. And she has "big hair" that has yet to be styled by a hairdresser from this century. Her body is the basic "mom" body shape: rather small and understated.

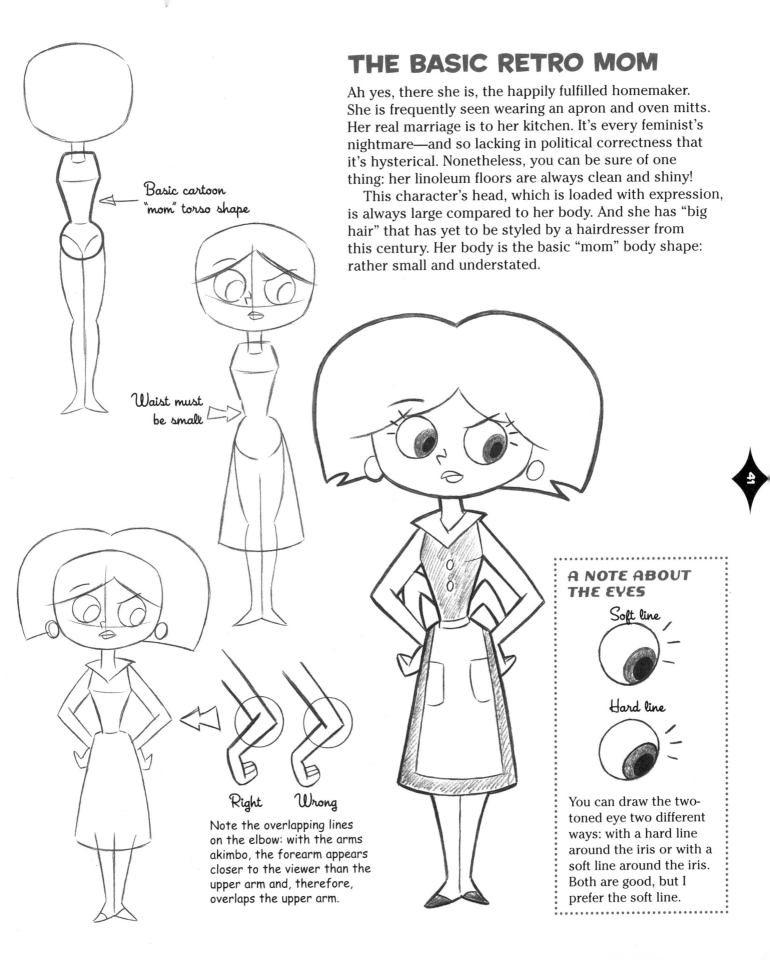

Basic cartoon "mom" torso shape

Waist must be small

Note the overlapping lines on the elbow: with the arms akimbo, the forearm appears closer to the viewer than the upper arm and, therefore, overlaps the upper arm.

Right Wrong

A NOTE ABOUT THE EYES

Soft line

Hard line

You can draw the two-toned eye two different ways: with a hard line around the iris or with a soft line around the iris. Both are good, but I prefer the soft line.

MOM HEAD PROPORTIONS

Here she is again, strolling back from the supermarket, just before she goes crazy. Just kidding (but barely). Again, notice how wide and oversized the head is. It's a great technique on moms, because the head then contrasts nicely with the smallness of her features, like her nose and mouth. Like most retro characters, her eyes stay big. Also, her clothes are never stylish but, instead, look like they came off the rack at a discount store.

The leg extends for a purposeful walk (when the dynamics of the legs must be convincing, it's a good idea to "sketch through" the dress to get the position correct, as in the next drawing).

Back curves outward to absorb weight of grocery bags

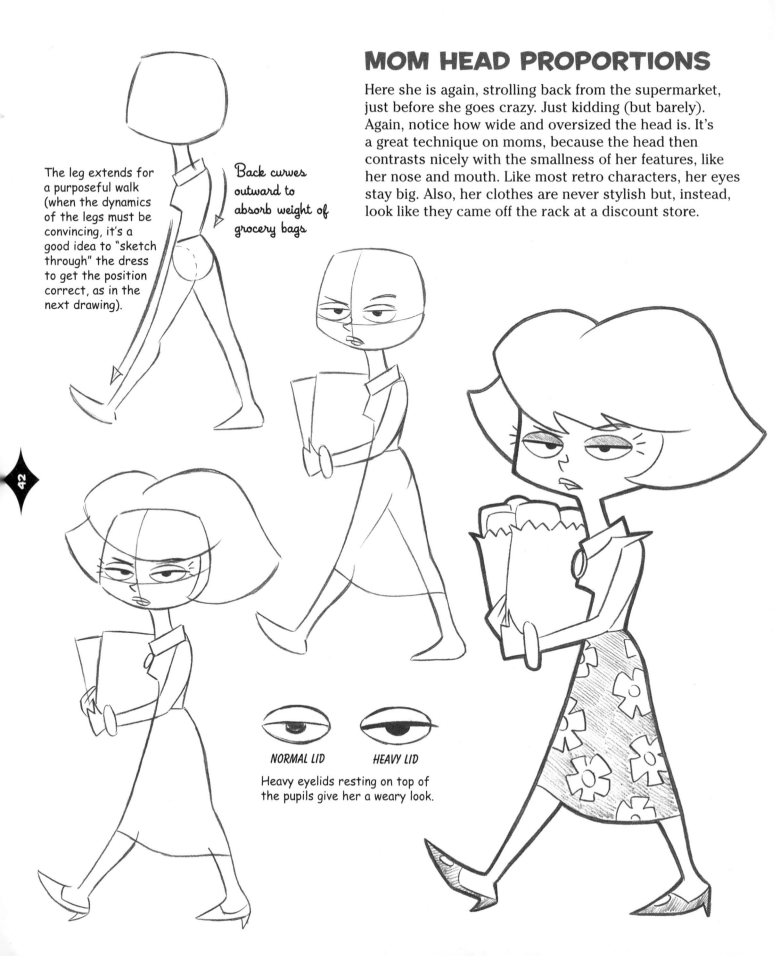

NORMAL LID HEAVY LID

Heavy eyelids resting on top of the pupils give her a weary look.

DANGER—MOM ATTEMPTING TO BE COOL

Oh yes, some mothers just cannot resist trying to fit in with the youngsters and using the latest lingo. Don't you just want to cringe when you hear a mom say, "Hi, homeys!" There should be some sort of corporal punishment for that.

Anyway, here she is, helping to lead the scout troop and enjoying the woods much, much more than the kids, who just want to get the heck out of there and play video games. Her appearance is always neat and tidy. The smile usually results in squinting eyes; this is a great look for this character, making her annoyingly cheerful—which is what you want. Play up the oversized eyelashes, which, in this case, are floating off the eyes.

Don't soften the point of the cheek— this angle *makes* the retro look.

This is a good side view of the typical "mom" torso.

The knees bend backward slightly when the legs are locked. (This only works for thin characters. Heavy characters don't exhibit this trait.)

The waistline is always higher on female characters than on male characters.

PERKY MOM

Many retro moms are typified by a relentless brand of perkiness. Make them bright eyed, with their eyelashes at attention. The posture, too, needs to be upright, reflecting a bubbly personality. Even her hair is spunky, for crying out loud!

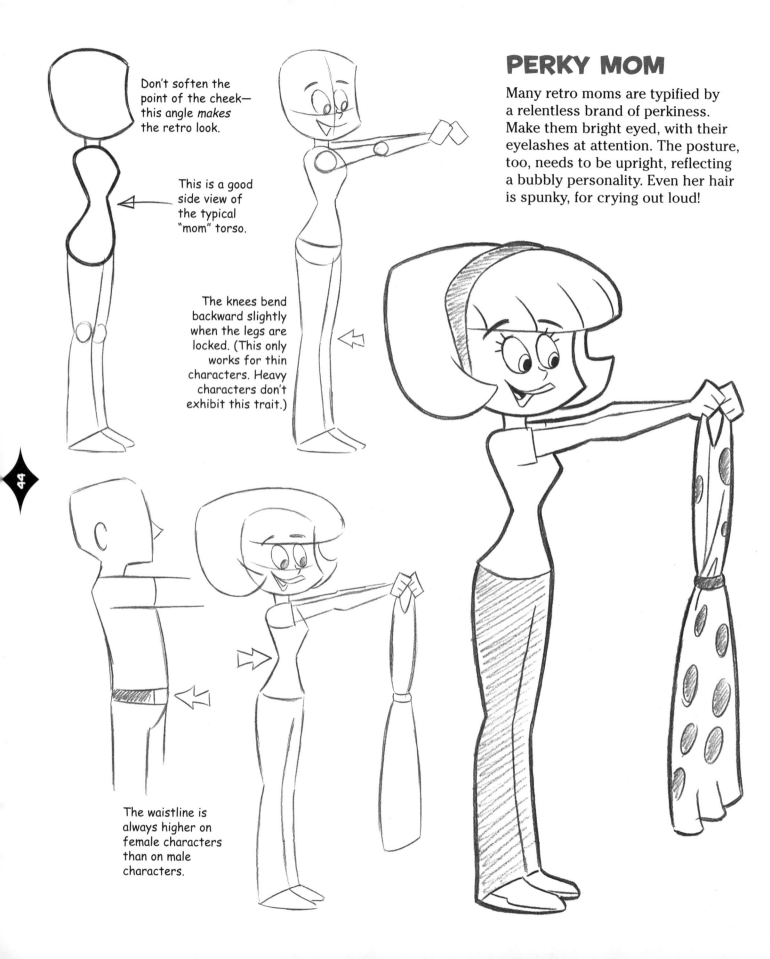

SHOP AROUND THE CLOCK

Yes, she's a shopper, but it's only to keep the fridge stocked with all sorts of great-tasting cheese products in a can. And lots of green Jell-O. Those headbands are ubiquitous on retro moms. A headband stands for "I'm so busy, I didn't have time to wash my hair today." And she doesn't need to either, because her hair should always look the same, no matter what. Not one hair out of place. And here's one more important note about the retro mom: her upper body is always short compared to her legs, and this holds true no matter what type of personality your retro mom has.

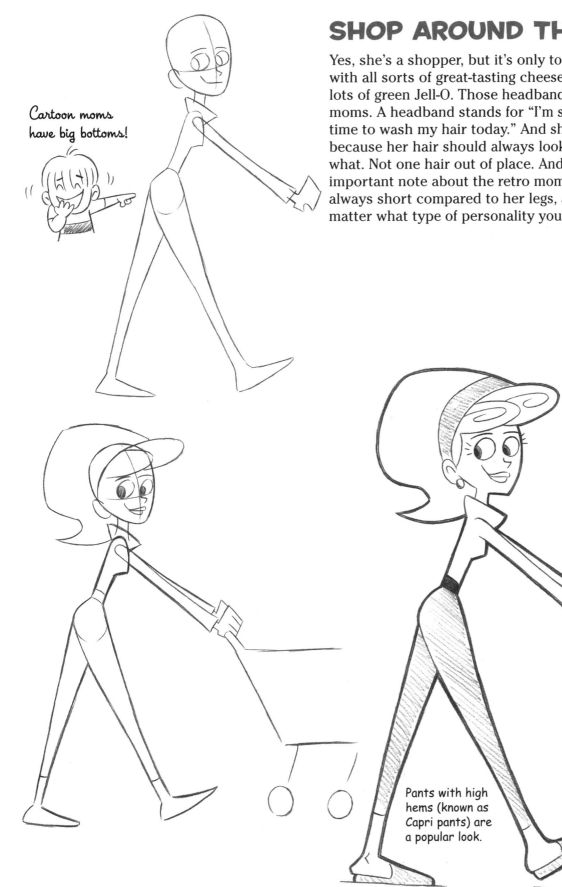

Cartoon moms have big bottoms!

Pants with high hems (known as Capri pants) are a popular look.

WALK-ABOUT MOM

Hair up in a bun, sleeveless shirt, and sandals. This is another good treatment for a mom character. This is the walking-about-town uniform for moms. You'll notice that even though her lower legs are skinny, they're not drawn as straight lines (a temptation among newer artists)—the calf muscles are still given shape and volume. And note the big feet: Characters who are dainty have small feet. Characters who are goofy have long feet. Don't hide the fact that she's goofy—flaunt it with a pair of flip-flops!

Center line helps locate middle part for hair

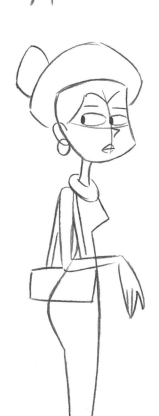

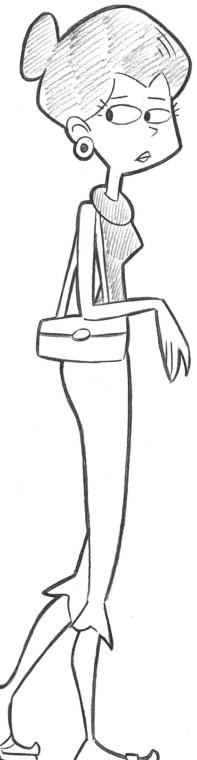

THE SADISTIC OLDER SISTER

Now we turn to the character type that everyone loves to hate: the cruel, older sister. She should have just come into her tweenage years (10–12). And she has but one mission in life: to torture her younger brother. There is absolutely nothing her younger brother can do that will not make her mad. She hates being forced to babysit when she could be out having fun with her friends. But, she doesn't hate it as much as junior does. Junior doesn't dare complain to his parents, because snitches are dealt with extra harshly in prison, er, I mean home. If she shoots her little brother a bold I'll-get-you-for-this glare across the dinner table, their parents will never notice it. To them, she is always their little angel.

The younger the character, the deeper the curve of the forehead

A NOTE ABOUT THE LINE OF SIGHT

When two characters make eye contact, it's imperative that the line of vision between them matches up. You should be able to draw a line from one character's eyes to the other's.

YOU ARE SO DEAD!

Yes, it's sisterly love at its finest. This stare lets you know that you're probably going to be the subject of an evil experiment in the pretend science lab. It's a well-established comedic technique to take one type of character and dress her in the opposite type of costume for her personality. The malevolent sister, therefore, is dressed up in a pretty bows and ringlets, which don't do a thing to soften her! Quite the contrary, the contrast heightens her crabbiness and makes her all the more amusing. (Notice that the bow on her head doesn't have soft rounded edges, but sharp pointy angles instead—just like her personality.)

Shoulders tensed, arms akimbo, and a direct stare at the reader is a great shot to use, whether the medium is animation, comic books, comic strips, or sassy greeting cards. It directly involves the reader and heightens the moment.

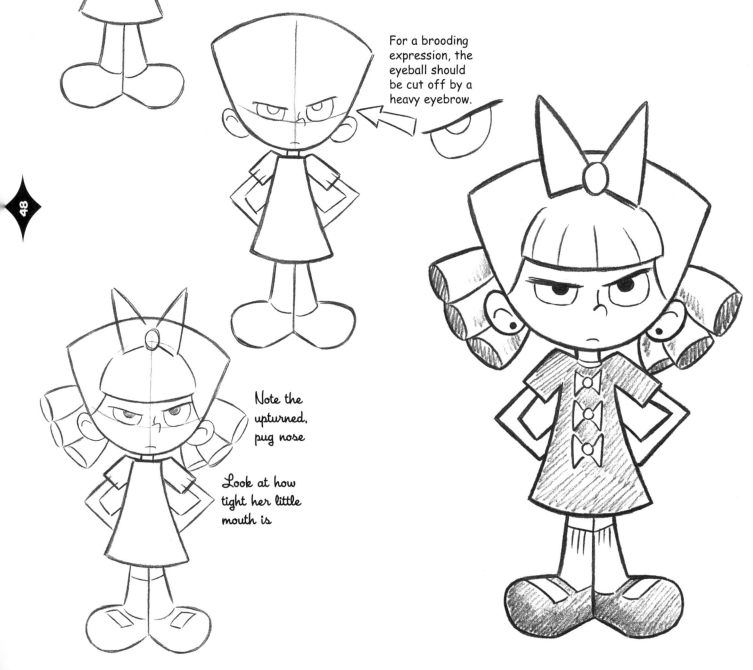

For a brooding expression, the eyeball should be cut off by a heavy eyebrow.

Note the upturned, pug nose

Look at how tight her little mouth is

DOLLS AND PAJAMAS

The mean sister has dolls that she plays with, just like anyone else. But when she's angry, she also punishes them, which is kind of weird. Still, she has to have an outlet, at least until her little brother gets home. Give your little dictator teddy bears and other sweet playthings. Teddy bears, in particular, can really take a punch. Pajamas remind the reader that this character is really just a little kid. Her outsized personality sometimes makes us forget that. "Feety pajamas," the kind that cover the feet and start every youngster off with her first case of eczema, are perfect because of their cozy appeal, which again contrasts with this character's wonderfully wicked personality.

Push/pull: when nose points up, mouth goes down

Ridiculously oversized bow

Big eyes combined with tiny nose

Skinny neck

Clothes slightly oversized

Oversized head

Funny ears

No shoulders

Big hair

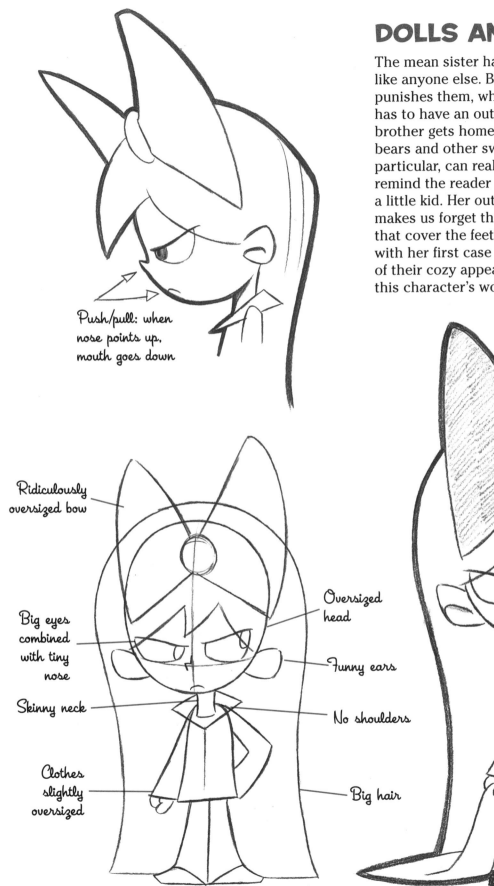

THE BRINGER OF BAD CHEER

It doesn't matter how well things are going or by how much her team is winning, the smallest, most innocuous thing her little brother does will set her off, big time. For example, he might beg their parents not to take him to see his bigger sister's cheerleading competition. But the clueless parents would insist that the whole family go to support her or she'll feel bad. Of course, she falls flat on her derriere and blames it all on him. You'll also notice that this character type is never good looking.

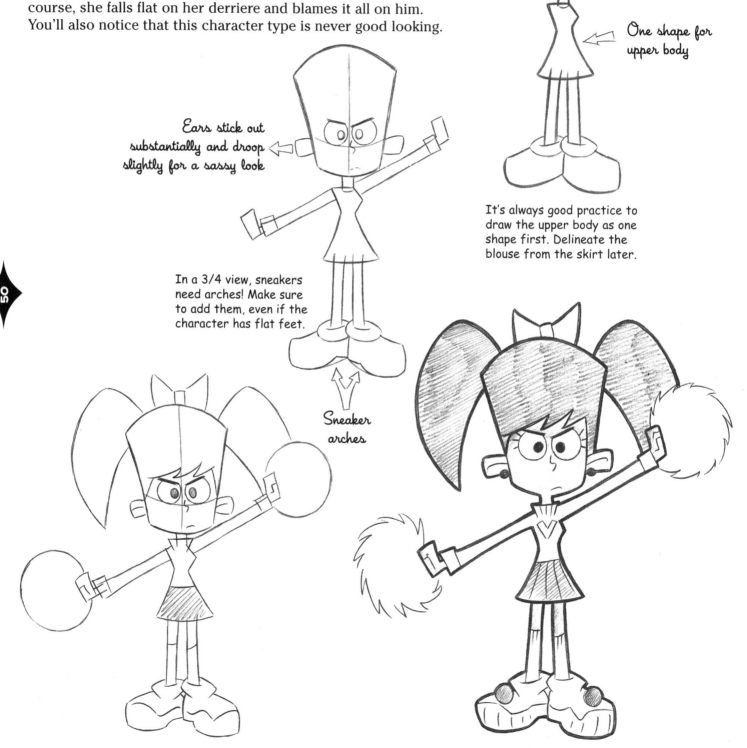

One shape for upper body

Ears stick out substantially and droop slightly for a sassy look

It's always good practice to draw the upper body as one shape first. Delineate the blouse from the skirt later.

In a 3/4 view, sneakers need arches! Make sure to add them, even if the character has flat feet.

Sneaker arches

THE KNOW-IT-ALL SISTER

This one's a tightly wrapped piece of work. She's got hair braided in tight, unlovely pigtails that are knotted so tight they're in danger of cutting off the blood supply to her scalp; oversized glasses; and teeth so big that at any moment she might mistakenly swallow her own chin. Her outfit should always be tidy, but embarrassingly square. Her know-it-all expression requires closed eyes and a smile. And, brainy characters always have huge heads compared to the size of the body. (The exception is the adult mad scientist, who can be tall and skinny.)

All of the features are gathered in the middle of her face.

Hairline doesn't travel through glasses

HOW TO DRAW BRACES

Draw small, horizontal rectangles on the teeth; these are connected to one another by one horizontal line running through them. But no matter how you draw braces, the most important thing to remember is to draw gigantic teeth first. If the teeth aren't big, you'll never see the braces clearly, the teeth will look cluttered, and no one will know what that stuff is that you drew on them.

EVIL AT HOME, EVIL IN CLASS

What better place to plot your revenge than seated behind your victim in class. It's as if the back of his head is calling to you, begging you to paste a "Kick Me" sign on his back. When drawing a seated character, there's a real advantage to drawing the chair first and then the figure. It's just so much easier to find the correct placement of the character that way. Also, a good approach is to show that young characters all but disappear behind the desk. Make sure the feet dangle in the air.

Pointy ponytail ends reflect her sharp personality

THE YOUNGER BROTHER

The younger brother is a sympathetic character. He can be quirky, nerdy, specially gifted, or neurotic. He should be funny, unthreatening in nature, and affable. Readers should like him. He has his own life to lead but is continuously distracted by the need to dodge the ambush of his evil sister, the string bean casserole served by his mom, and the camping trips planned by his dad.

REGULAR KID

This younger brother type gets a semicool haircut and a pair of jeans. He has a bright-eyed look. Thin legs work well in combination with oversized jackets, but make sure the jacket looks puffy, not tight. One way to do this is to draw the jacket as if it were sewn in sections, like ski jackets filled with goose down. Overstuffed backpacks are a fixture on youngsters today, who have to haul fifty pounds' worth of textbooks on their backs eight hours a day. If the country has an epidemic of scoliosis outbreaks in the next decade, you'll know why.

TEACHER'S PET

Admit it, he's a funny character. But the important thing to ask yourself is, Why does he strike you as funny? It's that retro look: the outline of his body dominates the entire character. That round oval of a body has not been modified to give him more convincing shoulders or hips. He remains a graphic design based on an oval. Also, his proportions have been incredibly exaggerated: he's only two head lengths tall.

MORE BOYS

THE RICH KID

This type of character is never named Jimmy or Billy. He's a Chip or a Fenton. Neatly groomed and nattily dressed, he's a funny supporting cast member. Maybe he's a friend of the younger brother. He could even be the boy the older sister has a crush on. Those half-closed eyelids give him a perpetually haughty demeanor. He only wears grown-up clothes, such as this jacket. He should look as if he were dressed to loll around the country club. And notice those sneakers: they're the type used for walking on the deck of a yacht, not for shooting hoops. Play sports? Gads, no!

Never show the neck of a rich character. Cover it with either a turtleneck or an ascot.

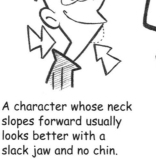

A character whose neck slopes forward usually looks better with a slack jaw and no chin.

ALL BRAINS, NO BRAWN

You can take this type of character as far as you like. You can cast him as a good student; a brilliant scholar; or, with the correct expression, a world-domination-desiring supergenius. He should have a very big head for the extra room his skull needs to house his superior brain (notice how the back of his head bulges), a puny body, and large glasses. And he has to dress like a nerd (notice the white socks and regular shoes—he doesn't own a pair of sneakers).

RETRO KIDS AND SPORTS

The star of a retro animated TV show, comic book, or comic strip is not a gifted athlete and is never going to be. That's a rule in retro cartoons. The gifted athlete gets the girl and makes the main character feel just two feet tall (although he only stands three feet tall as it is). To be the star of a show, a character needs obstacles—many of them. Problems, burdens, challenges—that's the stuff your character has to battle and overcome. It's his inventiveness that'll get him there. That's what makes a winning character—someone who can summon his inner strength and make an idiot of himself anyway. A star athlete, on the other hand, has it all going for him already. He's not interesting. He's one-note. He's a jock, period. Therefore, your guy has to look a little outclassed in his sports uniform. *Note*: The same physical ineptitude is equally endearing for female characters.

Note the different directions the outline of the face takes.

COOL RETRO Action* POSES

There's a lot of action and movement in cartoons. Action poses heighten the level of intensity and can be hilariously funny. Traditionally, a cartoonist will draw a character in action with lots of movement, complete with flailing arms and legs. Nothing is spared or conserved. Everything goes full out. The movements are fluid.

But this is not the case in retro cartoons. Instead of working to give the reader the feeling of action, retro cartoons are only interested in humorously caricaturing an action—making fun of it, stereotyping it. Often, this leads to stiff poses, which are very funny because they make the actions look silly and colossally ineffective.

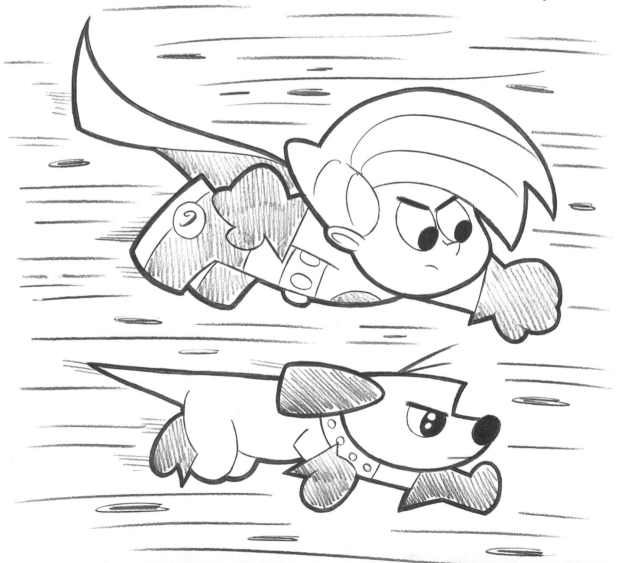

TRADITIONAL VS. RETRO ACTION POSES

Action poses are used in two circumstances: first, when depicting an action, such as running or punching; and second, when an emotion is so strong that it calls for a strong pose, such as laughing insanely. The following techniques for creating caricatures of action poses are really at the heart of what retro cartoons are all about, and this is where you'll most likely start to get the essence of the style at a gut level. The name of the game is to conserve motion and stiffen the pose. To see how this applies to actuals figure in motion, let's start with a typical example: throwing a ball.

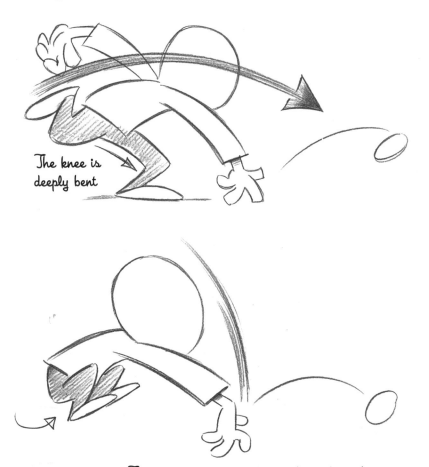

The knee is deeply bent

Tuck legs and feet underneath, making them useless for adding power to the throw

TRADITIONAL THROW

The arrow shows how the entire figure is traveling in the direction of the throw. As in a "walking pose," one arm is forward and one is back; one leg is forward and one is back. Everything is in motion, and as a result, the pose is quite convincing.

RETRO THROW

Here, as little movement as possible is used. Only one arm is shown. The legs mirror each other, conserving motion. The throwing arm is straighter (stiffer) than in the traditional approach. Speed lines are used to add a feeling of motion to the throw.

TRADITIONAL REACH

Even a simple motion like reaching for something can be made to look retro by limiting the movement. In the traditional style, the character goes all out to reach for something, pulling the body off balance in the process. The arm stretches in length as it reaches.

RETRO REACH

In the retro version, the character's posture remains stiff as he reaches.

INTROVERTED POSES

Introverted poses—those in which the character draws into himself—make excellent retro poses. In classical cartooning, we learn that these are not good poses because they would be hard to read as silhouettes—and that's true, for classical cartooning. But in retro cartoons, the closed-in ball of a figure is funny and, therefore, effective.

SCHEMING

THE MEGAPUNCH

We always think of the punch as a full body action: everything goes into it. And, yes, even retro cartoon characters need a big haymaker to win a fight against evil mutant aardvarks and other extraplanetary scum. But the approach is quite different from the traditional style.

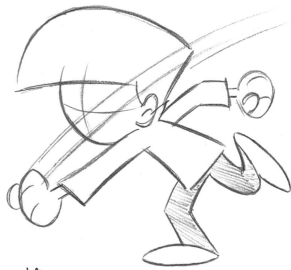

Nonpunching arm stays pasted to body

Small speed lines trail from heels

Pulling toes up makes a pose funnier

RETRO PUNCH

The all-out retro punch is as stiff as a board! There's actually no momentum being generated by his body posture whatsoever! He's flying through the air, horizontally, with an arm out, and yet, it's so goofy that it works. But, it's necessary to turn the background into a canvas of speed lines, otherwise, he'd look like a statue frozen in air.

TRADITIONAL PUNCH

Again, the "walking pose" is the model for the punch: one arm is forward and the other is back; one leg is forward and the other is back. The body leans into the punch, and one foot is off the ground. It works, but we've all seen it before, many, many times.

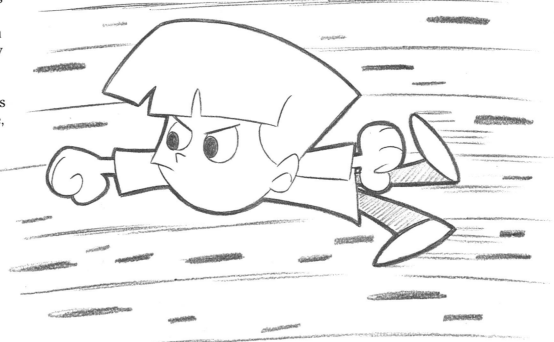

FLYING

We're all used to the classic pose of an action hero charging up into the air to save a worthless city from an evil monster who might actually gentrify the place and make it interesting. How do you simplify the pose to make it more retro? Take a look.

CLASSIC

One arm is up; the other is held out for balance. One leg is up; the other is down.

RETRO

Both legs are pasted together, conserving energy. The trailing arm is pasted at his side, too. Remember: the closer the body can tuck into itself, the more retro the pose becomes; loose limbs are for traditional cartoons.

Downward-tilting feet reflect wind drag

THE RETRO "TAKE"

You know what a "take" is. It's when a character goes, What the heck? and then looks startled with an extreme reaction. It's used many times in all sorts of cartoons. There's a very cool way to show a take in the retro style that's different from anything in classic cartoons.

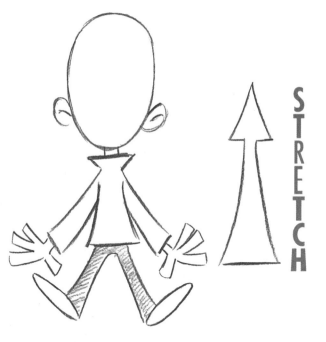

CLASSIC TAKE

The figure stretches and thins out as the take occurs. All the limbs straighten out—even the ears stick out! This is a lot of body movement, and the figure will then end up bouncing back (recoiling) to its previous size.

STRETCH

RETRO TAKE

The character's form doesn't stretch at all! Instead, the character is drawn on a tilted axis, with a hypnotic swirling background. Very cool—and funnier.

MORE ACTION POSES

RUNNING

Conserve motion by eliminating the swinging arm movement that you see in traditional cartoons.

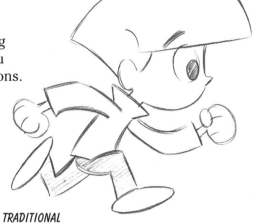

TRADITIONAL

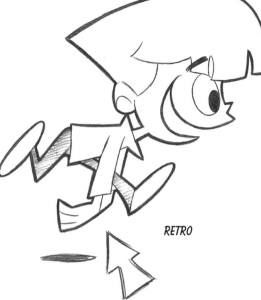

RETRO

Tilt hands backward at wrists for a funny look

LEANING

Even a pose as breezy as leaning against a surface can be done in a funny, retro way. Again, conserve the movement and bring the body inward.

TRADITIONAL

RETRO

KARATE KICK

A karate kick will be retro if you focus more on the attitude than on the technique of the kick itself. Look how much less motion there is in the retro kick than in the traditional one.

TRADITIONAL

POW

RETRO

THE EPIPHANY

This is perhaps the most intense action pose of all—and it requires a background to reflect the character's state of mind. This kid has just had a brainstorm, and literally, an electrical storm is occurring behind him. Although his limbs are outstretched, they're stiff, and there's no direction to his movement. Think about it: is he going up, down, or sideways? Actually, his body is frozen in air. He's not moving at all! He's just floating above the ground, having an intense moment. This action pose has actually eliminated every hint of action! That's retro.

THE RETRO FAMILY Pet

All retro families have a retro pet to go with their 2.3 children, 2 cars, and chocolate fudge breakfast buns. Pets make great supporting characters and must be drawn in keeping with the style of the family unit as a whole. The most popular pets are dogs, cats, birds, and fish—in that order. If the point of a cartoon dog is to appear lovable, then the point of a retro cartoon dog is to appear so lovable it's weird. These are pets who need therapy.

THE CARTOON DOG

Let's compare the regular dog to the retro dog.

TRADITIONAL

This is a simplified version of an anatomically correct pooch. Notice that the head dips at a 45-degree angle in a relaxed stance.

Pointy back of head

No bump in shoulder

Big, round rump

Front end of snout is fatter than jaw area

RETRO

This is what happens when a dog learns to operate a can of cheese spray.

Sagging tummy

No dew claw, creating a sleek leg line

Pronounced heels

PUPPY DOG EYES

When dogs want something, they generally stare at you mercilessly until you toss them a scrap. Cartoon dogs take that one step further. Their eyes actually change shape and size when they pull on your heartstrings.

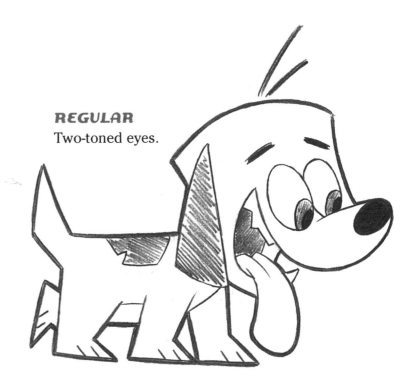

REGULAR
Two-toned eyes.

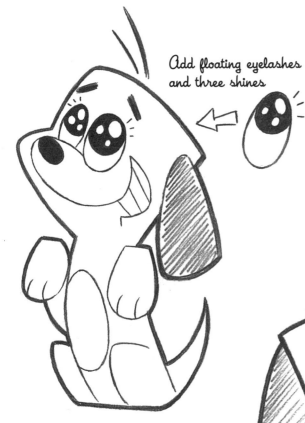

Add floating eyelashes and three shines

BEGGING

The eyes get larger, and the irises are eliminated. All that's left are these large, black pools of glistening puppy eyes. In order to make them glisten, you've got to add the glisten part: make the eyes as dark as possible, and stuff multiple shines into each one. Also, eyelashes should suddenly appear.

SAD

Sad eyes are puppy eyes at their absolute largest. No matter how evil this dog has been just a second before, the moment it turns on the water faucets, it's curtains for any human. Nobody can stand up to this treatment. It simply can't be done. The black eyeballs take up almost all of the room inside the eyes. The shines are huge. Tears well up on the bottom, as one droplet squeezes out onto a cheek.

Exaggerate ear length in this pose

COMMON HOUSEHOLD DOG BREEDS

BEAGLE

Here's the ever-serious beagle. The beagle is a hound with a perpetually furrowed brow, a small frame with a large head, and a compact body. This breed looks like a puppy at any age. Note the markings on the legs, which look like a pair of tall white socks.

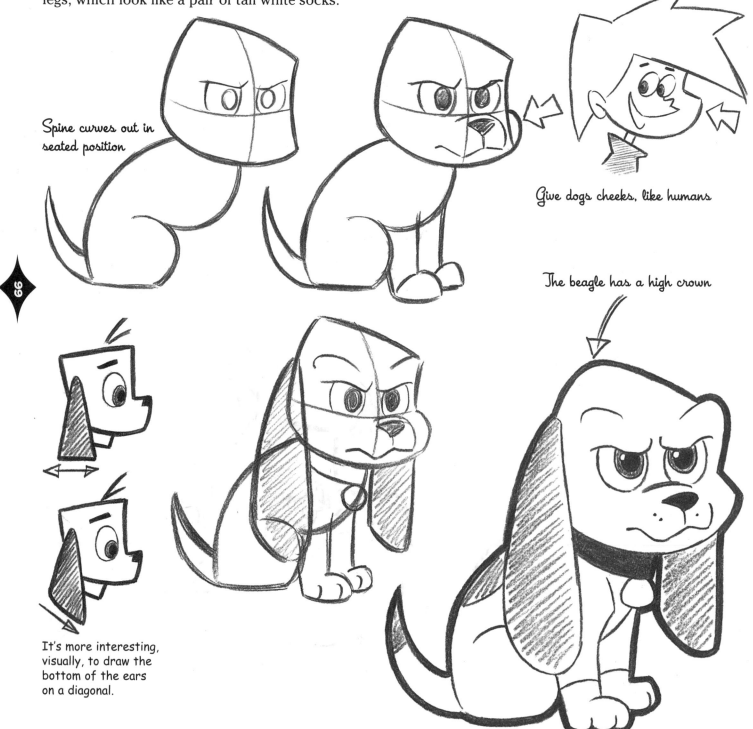

Spine curves out in seated position

Give dogs cheeks, like humans

The beagle has a high crown

It's more interesting, visually, to draw the bottom of the ears on a diagonal.

BULLDOG

The most common cartoon dog is the bulldog, which is characterized by its big jowls, large chest, tiny waist, and inward-facing front legs. This breed is owned by the antisocial next door neighbor and his bully son. Note the construction of the bulldog body: There's a high, arching back, but a relatively horizontal line for the tummy. The legs should look ridiculously small for the body. The rings around the eyes should make it look as if the dog hasn't slept for weeks. The collar is usually insanely aggressive. I have "floated" the ears to give the drawing a touch more style.

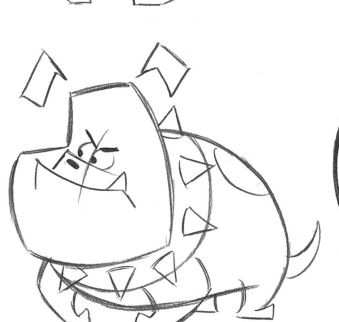

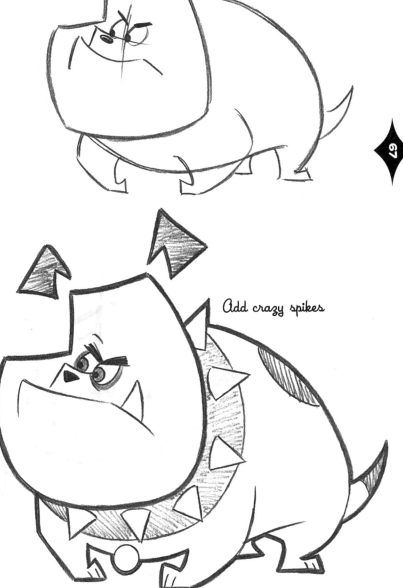

Add crazy spikes

AFGHAN HOUND

This dog is owned by a family that has to have just the right type of dog to match the window treatments in the house. The Afghan's head is frozen in the "up" position so that the dog has to look down its nose at everyone. To maintain this aristocratic appearance, make sure the ruffles only appear at the bottom of the coat; the top is smooth.

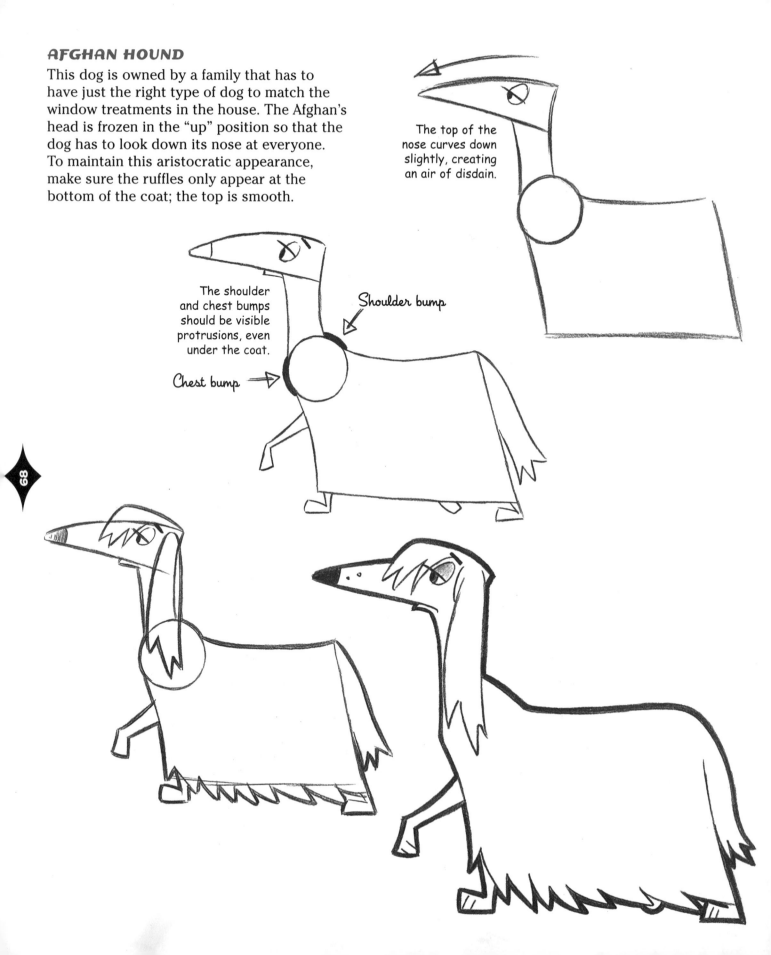

The top of the nose curves down slightly, creating an air of disdain.

The shoulder and chest bumps should be visible protrusions, even under the coat.

Shoulder bump

Chest bump

MUTTS

Cartoon mutts are goofy, hungry, and lazy. "You threw it, you get it," is their idea of a game of fetch. They're very popular cartoon pet types because they're the everyman of the canine species. They're the canine equivalents of human underachievers—smart but never fulfilling their potential.

Chest area overlaps rump in this pose

MUTT WITH BONE

The crossed paws are a good look for a dog lying on its tummy. Note the overlapping shapes that make up the body. Forward-hanging ears are a nice variation.

The higher the smile rises on the face, the goofier the character will be (this principle applies to humans, too).

A sway back is goofy

Don't forget ever-present puddle of drool

When the tummy hangs low to the ground, there needs to be a cast shadow on the ground underneath it.

BIG-NOSED MUTT

The big honker is a great look for a silly mutt. It immediately telegraphs "Not a purebred." Add an uncoordinated tongue dripping with saliva for an extra helping of silliness. Skinny ears and teeny feet contrast well with that big belly. Sharp teeth work better than flat ones for retro cartoons; flat teeth humanize a dog, whereas sharp teeth give the character an edgier look.

CATS AS PETS

Cartoon cat personalities vary widely from cute to evil, with a lot more emphasis on evil. Their looks also vary widely: some are roly-poly, others are slinky, and some are just lovable little fur balls. Cats have looser skin than dogs, and therefore, their anatomy is more concealed to begin with. Because of this, when they're exaggerated and turned into cartoons, greater liberties can be taken with their form. So, you don't need pay as much attention to their correct anatomical construction (the way their joints bend) as you do with dogs. This frees you up to create highly stylized versions of cats.

ANATOMICALLY CORRECT CAT

Notice that the cat's chest is smaller than its waistline or rear. The legs are thin, and the knees are perpetually bent (just the thought makes me want to rub on some sports cream!). The tail has the same thickness throughout. The neck is long, and the head is tiny, where it houses an evil brain.

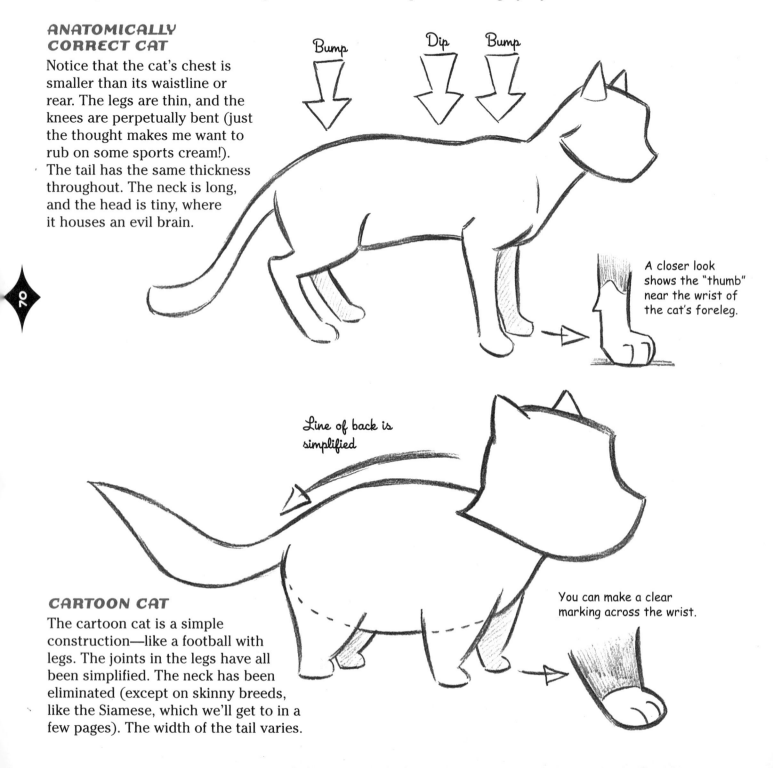

Bump

Dip

Bump

A closer look shows the "thumb" near the wrist of the cat's foreleg.

Line of back is simplified

You can make a clear marking across the wrist.

CARTOON CAT

The cartoon cat is a simple construction—like a football with legs. The joints in the legs have all been simplified. The neck has been eliminated (except on skinny breeds, like the Siamese, which we'll get to in a few pages). The width of the tail varies.

BASIC CAT HEAD SHAPES

There are two basic cat head shapes: round or with pointy cheeks. And within these categories, there are many variations. In addition, you can invent as many different shapes as you like by stretching and squashing the head.

BASIC ROUND SHAPE

BASIC POINTY-CHEEKS SHAPE

ROUND AND SMOOTH

The outline of the face is completely intact (below). A few hairs are added to the top of the head. Strands of hair are drawn as lines whereas ruffles (right) are drawn as spikes that have thickness.

ROUND AND FLUFFY

With retro cartoons, none of the ruffles should appear soft. Instead, sculpt each ruffle like a pointy piece of plastic. The ruffles generally appear on the cheeks and on the tip of the tail.

POINTY CHEEKS ON KITTENS

Even though real cat cheeks never puff out into a point of any kind, for reasons known only to the cartooning gods, audiences expect to see their cartoon cats with pointy, ruffled cheeks. This works especially well when depicting soft, fluffy cats and kittens. Kittens all have tiny noses. Being young, these characters have eyes placed low on the head, as well. The ears and tail can be small or large, but I prefer tiny ears and a big, fluffy tail. It makes them seem more pampered. For a retro look, keep the eyes two-toned with eyelashes stiff and at full-alert.

THE SIAMESE CAT

Notice that there's never a Siamese kitten. That's because kittens are supposed to be cute—but there's no such thing as a "cute" Siamese cat. (Now I'm going to get hate mail from someone with a cute Siamese cat. Okay, pal, I didn't mean YOUR cat, I meant everyone else's, all right?)

These cats are always sinister and slinky, with hearts of darkness. They must have true "cat eyes"—almond-shaped eyes thick with eyeliner. Siamese cats have long, thin tails that curl in strange ways. Note the typical Siamese markings: not black spots, but areas of gradual blackening on an otherwise smooth, grayish-beige coat. Give them long whiskers—a sign of cartoon villainy. I like to make their ears large, as if they're always ready to overhear something that's being whispered. Elegant in an evil way, their legs are thin and delicate.

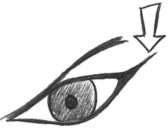

DRAWING THE EYE OF THE SIAMESE CAT

Trailing streak

The eye of the Siamese cat should look like it has been gone over several times with eyeliner, with a trailing streak off the end.

SURLY CAT

This cat is unhappy and glad about it. The brow remains no matter what the expression. All of the features are crumpled tightly together at the center of the face, resulting in a not-too-cheery countenance. The lower eyelids hang heavily, which is the opposite of bright eyes. And the paws become chubby little fingers. Notice the vastly oversized head that characterizes most retro-style animals. Real cat heads are actually quite small.

Cat ears tilt out at a 45-degree angle

Note the furrowed brow

POSITIONING THE WHISKERS

Whiskers up for friendly cats

Whiskers down for evil and grumpy cats

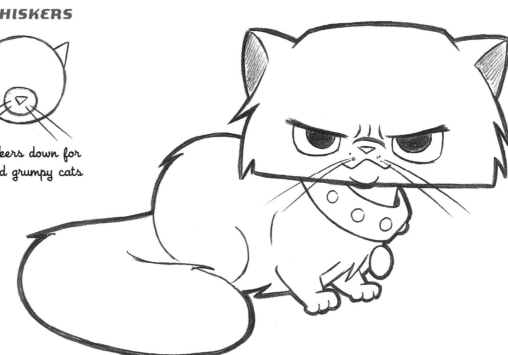

BIRDS AS PETS: POPULAR TYPES

Household birds are so retro. If you can't have a pink flamingo on the front lawn, then a feathered pet in a standing cage is the next best thing for kitsch. Birds are very compact little creatures. Since they don't have buckets of personality, they have to be highly stylized in order to create personality. You do this by making them chunky and creating designs for, rather than literal representations of, their feathers and beaks.

COCKATOO

In cartoons, the crown of feathers is the main thing with this breed. Under that punk feather-do, he's just a little guy (even though in reality, the cockatoo is a large bird).

PARAKEET

Parakeets are very cute. And although they resemble parrots, their heads are not as big in comparison to their bodies. They are chestier, smaller in size, and more squeezable.

A NOTE ABOUT PARROT FEET

SMALL BIRD FOOT

PARROT FOOT

Unlike most smaller household birds, parrots have thick, ugly claws that need to be caricatured when drawn for cartoons. The feet of smaller birds can be drawn as simple lines.

PARROT

The parrot has much more beak in relation to its head than other domestic birds. Since, in reality, birds have one eye on either side of the head, you would only see one eye when they are in a profile or 3/4 position like this one. And that limits their expressiveness. Therefore, I like to group both eyes together on the same side of the head. It results in a goofier look.

FLOATING

Note that I've "floated" (detached) the tail to give it an extra-graphic look (above left). You can float anything you like on a character. Just look at the baby chick above, on which I've floated an eye, an eyebrow, and the hair on the top of the head.

CANARY

This is probably the most popular of all pet birds, so here are three variations to get you started drawing your own versions. Whereas the cockatoo, parrot, and parakeet all have full bottom beaks, the cartoon canary should have very little, if any, bottom beak—for a petite look. The upper beak does not hook over. They are smooth, gentle little creatures.

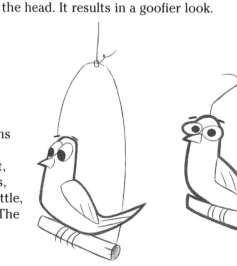

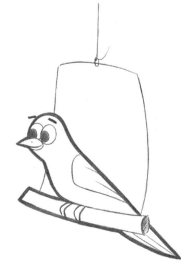

74

TROPICAL FISH AND AQUARIUM PETS

Even the aquariums get into the pet act. They're so irresistibly banal. What's the point of being a fish in a tank anyway? For a sea horse, what makes it a good day versus a bad day? Cartoons get pretty deep, philosophically, if you think about it. Okay, enough Descartes; back to the fish. Here are some cool types for ya.

COOL RETRO Teenagers

Teenagers are popular characters who divide their time equally between family, school, social life, and saving the world from the forces of evil. Their faces are generally sleeker, and their bodies lankier and longer-legged, than preteen characters.

Each teenage character must have a specific personality type. It's not enough to just draw a teenager. What kind of teenager? Is she the popular kid? Is he the computer geek? Is he the class clown? Is she the rebel? If I can leave you with one important lesson, it's this: you're not drawing cartoons; you're drawing characters. Some artists will decide on the character type before they begin to draw so that they'll have a clear vision of where they want to go. Other times, it may work better to start sketching freely and then, once a character begins to emerge, start refining it along the lines of a specific personality.

SERIOUS TEENAGE BOY

Here's a popular, intense character type who is great for action-comedy shows. The first thing to notice is that the chin is longer and more angular than it is on younger characters. The entire head has a leaner, less-rounded look. (On female teens, however, the round look can still be maintained; see page 79.) But the nose should still be upturned— a sign of youthfulness. The teen hairstyle makes a fashion statement. Notice the hair falling dramatically over the forehead. The eyebrows show determination. Teens are often intense.

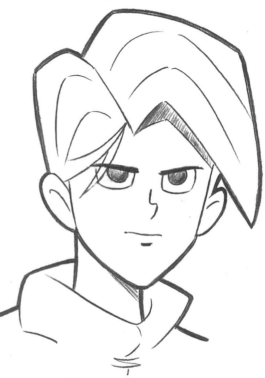

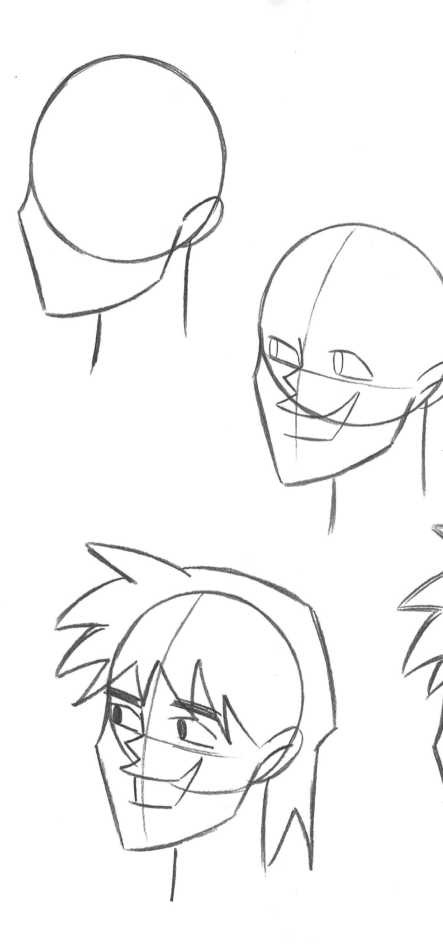

CAREFREE TEEN

The head is, again, sleeker and more angular than it is on younger characters. Thick eyébrows are used. The eyes have an open style (in which the lines indicating the shape of the eye don't meet at the corners but remain open). This is a popular look for comic books and adventure-style animated shows. The upper eyelid needs to be slightly darker than the lower one. A few light sketch marks under the eyes bring the illusion of color to the cheeks.

Keep in mind that retro cartoons deal primarily with young teens, so these characters are not yet fully matured physically. This shows in the neck, which is not as thick and muscular as it would be on an older type of hero. Older teens and twentysomethings are better suited to a manga or classic American comic book style.

PRETTY TEEN

Notice the direction of the pose here, which changes at the hips. This is a more mature stance that children and tweens never assume. Plus, teenage legs are significantly longer than the upper body. The eyes have taken on an almond shape, replacing the circles that characterize the eyes of younger characters. The eyebrows are sleek and close to the eyes, and are not the stiff, funny lines used for younger kids and tweens. And, the lips are much fuller than on younger characters. The nose, however, stays just as small as before and, in some cases, gets even smaller.

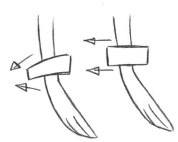

Draw uneven lines—parallel lines are boring

Capri pants can flair out for style

THIN VS. THICK

Compare the version of this character drawn with a thin outline to the one drawn with a thick outline and jazzier clothes. I think the thicker outline adds more punch to the image.

78

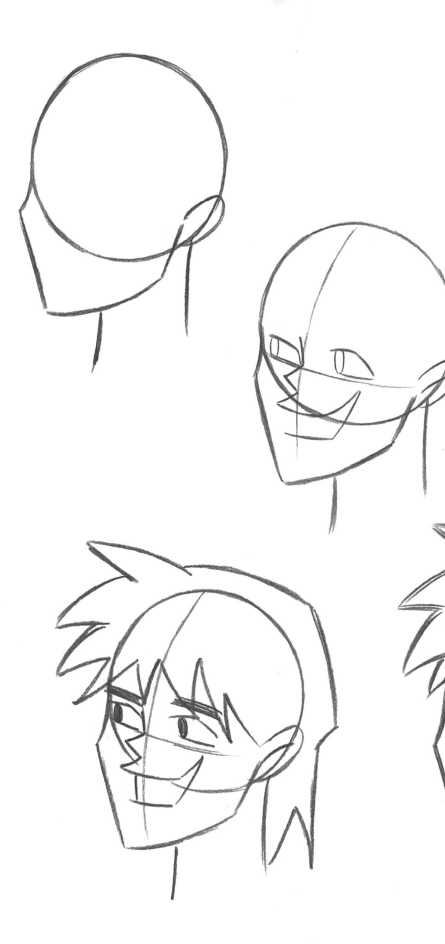

CAREFREE TEEN

The head is, again, sleeker and more angular than it is on younger characters. Thick eyébrows are used. The eyes have an open style (in which the lines indicating the shape of the eye don't meet at the corners but remain open). This is a popular look for comic books and adventure-style animated shows. The upper eyelid needs to be slightly darker than the lower one. A few light sketch marks under the eyes bring the illusion of color to the cheeks.

Keep in mind that retro cartoons deal primarily with young teens, so these characters are not yet fully matured physically. This shows in the neck, which is not as thick and muscular as it would be on an older type of hero. Older teens and twentysomethings are better suited to a manga or classic American comic book style.

PRETTY TEEN

Notice the direction of the pose here, which changes at the hips. This is a more mature stance that children and tweens never assume. Plus, teenage legs are significantly longer than the upper body. The eyes have taken on an almond shape, replacing the circles that characterize the eyes of younger characters. The eyebrows are sleek and close to the eyes, and are not the stiff, funny lines used for younger kids and tweens. And, the lips are much fuller than on younger characters. The nose, however, stays just as small as before and, in some cases, gets even smaller.

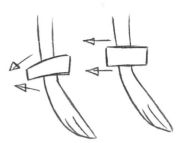

Draw uneven lines–parallel lines are boring

Capri pants can flair out for style

THIN VS. THICK

Compare the version of this character drawn with a thin outline to the one drawn with a thick outline and jazzier clothes. I think the thicker outline adds more punch to the image.

Hair is smallest at origin of ponytail

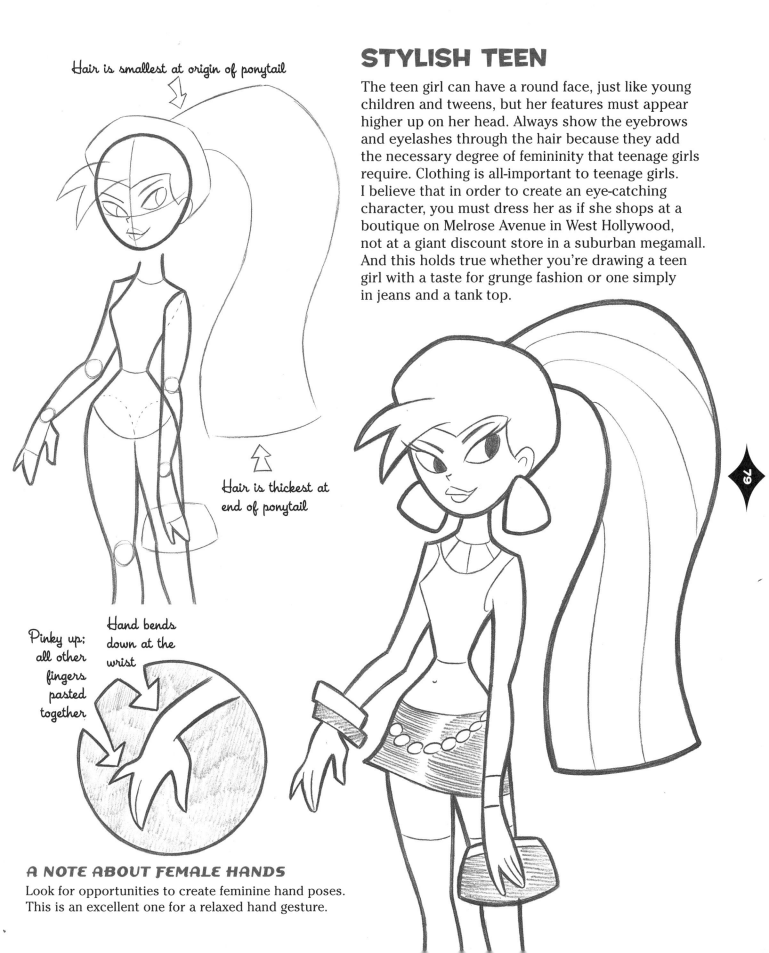

STYLISH TEEN

The teen girl can have a round face, just like young children and tweens, but her features must appear higher up on her head. Always show the eyebrows and eyelashes through the hair because they add the necessary degree of femininity that teenage girls require. Clothing is all-important to teenage girls. I believe that in order to create an eye-catching character, you must dress her as if she shops at a boutique on Melrose Avenue in West Hollywood, not at a giant discount store in a suburban megamall. And this holds true whether you're drawing a teen girl with a taste for grunge fashion or one simply in jeans and a tank top.

Hair is thickest at end of ponytail

Pinky up; all other fingers pasted together

Hand bends down at the wrist

A NOTE ABOUT FEMALE HANDS
Look for opportunities to create feminine hand poses. This is an excellent one for a relaxed hand gesture.

COOL CAT

He's a caricature of the 1950s jukebox/malt shop teen turned into a present-day character who bops around with a little extra bounce in his step. These types are really fun characters to draw. Give him a modified Elvis haircut and tight-fitting jeans. Leave his shirt untucked, with the collar up. The long, thin neck repeats the motif of his skinny legs. Note the thicker eyebrows, which give the face a little more impact.

HANGIN' AT THE MALL

Once again, we see that teenage girls are very put together, with expensive outfits that are bleeding their parents of their retirement savings. This is an example of an oft-used, cartooning technique: placing superlarge heads on very thin, long bodies. This is different than putting very large heads on very short bodies, as is done effectively with children. The ultraslender body emphasizes that she's still not a mature character. It's also important that you maintain the hairstyle of a teenager, such as this ponytail. (Note the eye shadow, which adds glamour to the eyes.)

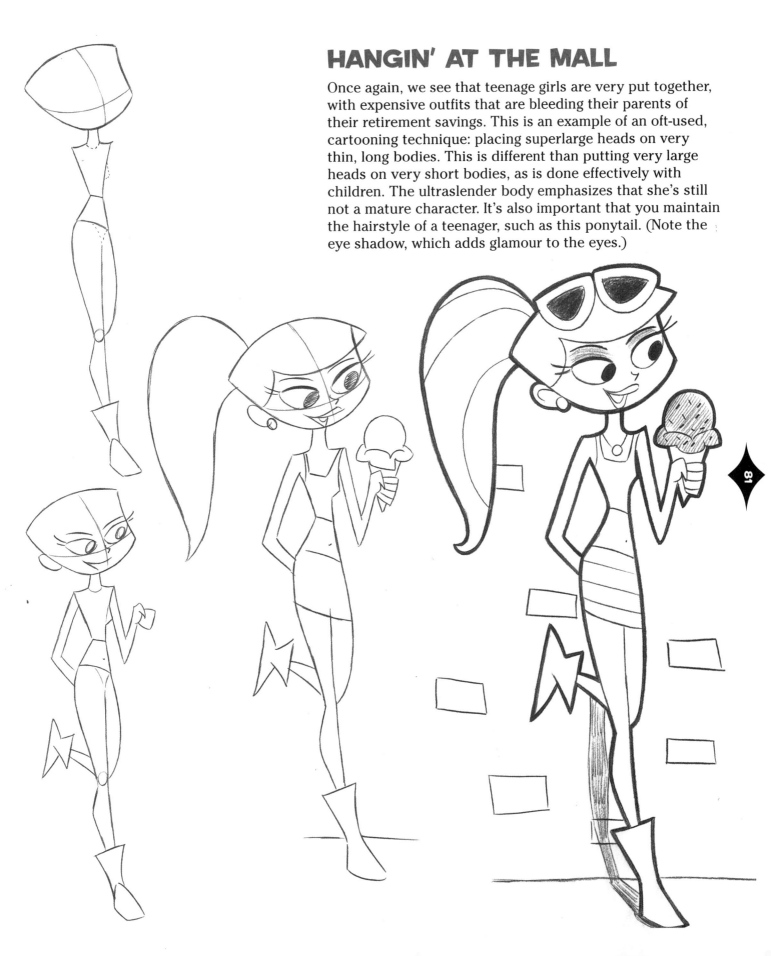

LOOSEY-GOOSEY TEEN

When he's older and in the workforce, he'll have to tuck in his shirt, roll down his sleeves, button his collar, and tighten his tie. But until then, he's still a kid. Long, thin legs; long arms; and a bit of a gangly neck are the hallmarks of a teenager.

A POPULAR HAIRSTYLE FOR TEENAGE BOYS

This is a cool look for a teenager and is worn by lots of teen movie idols. It features a center part, with the hair cropped in a sharp line at the bottom.

Note the outward bump of the forearm, which shows some of the muscles of the character without making him appear muscular.

Hair falls in front of face

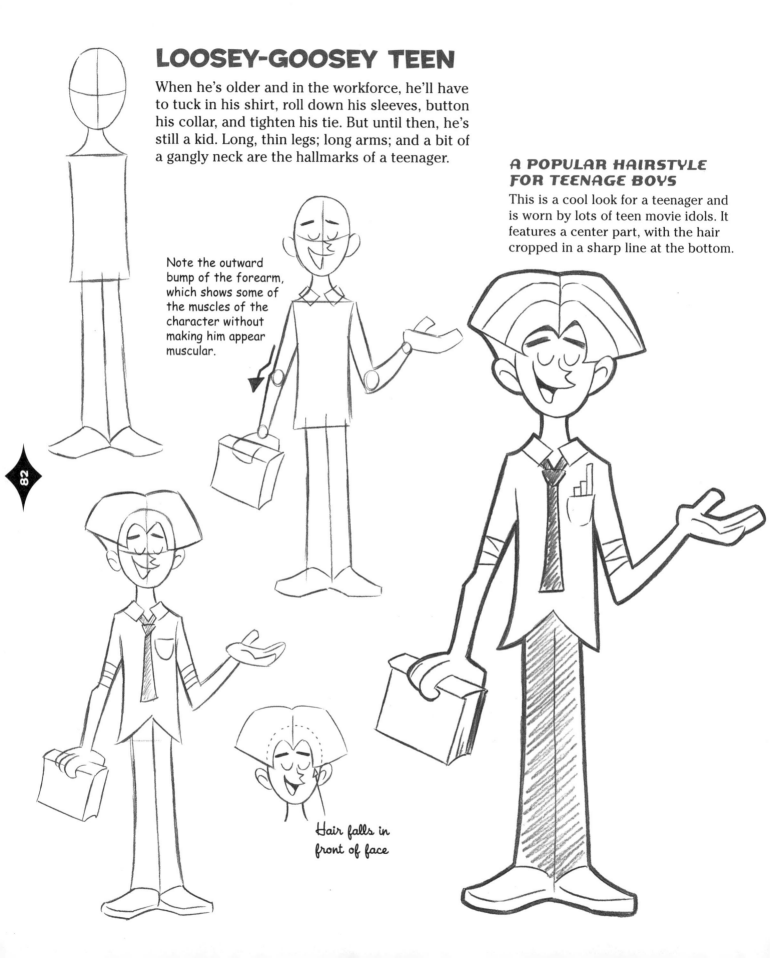

THE GIRL NEXT DOOR

This is a very clean and wholesome look, but the character is also attractive and stylish. Gone are the days when the girl next door looked like something your mother had to bribe you to ask out on a date. Make her bright eyed, which means eyelashes that stand up straight, rather than trailing off with a stilettolike flair. Teens have the same accoutrements as grown-ups: purse, earrings, makeup. The strands of hair in front of the ears is a look borrowed from manga, which is growing in popularity.

Heel
juts out

SCHOOL SCENE

This is your typical hallway-roaming, cafeteria-chatting, football-playing, math-class-snoozing teenager. Schools come ready-made with great characters and locales for staging scenes: cliquey girls gathered at the lockers; rich kids being driven by limo past the kids at the bike racks; students choosing glow-in-the-dark food groups from the vending machines; evil teachers involved in secret projects in the science lab; geeks with delusions of grandeur in the computer rooms. You name it, it's there. And this forces social interactions and groups, which are great for comedy.

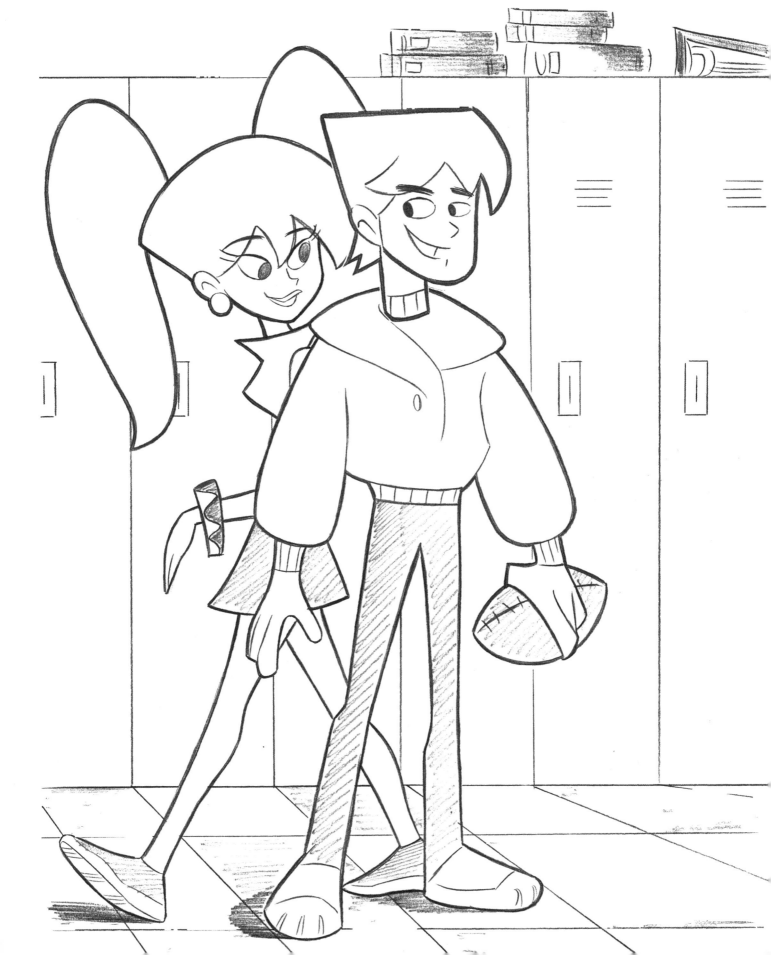

THE REBEL

Teen characters in action comics and animated TV shows are characterized by their readiness to fight for what they believe in. Teens relate to feelings of heroism, nobility, and triumphing over struggle. And since growing up as a teen is, in fact, a struggle for everyone, this makes for an appealing character.

Heavy eyebrows provide an added look of intensity.

Hair is tossed loosely

Fists turned out are weak

Fists turned in are strong

POSTURE

Your character can stand at attention, can stand impatiently, or can stand nervously—but you don't want your character to just "stand." You have to put a spin on it. Posture is to the body what expressions are to the face (except that your mom never tells your face to stop slouching). Posture is either high energy or low energy, extroverted or introverted, based on the character's thoughts at the moment. In fact, a character can stand in one place but change posture many times in response to a series of thoughts. And while a character's face may try to conceal a thought or feeling, the body doesn't lie. A well-positioned body reflects an attitude, thought, or emotion.

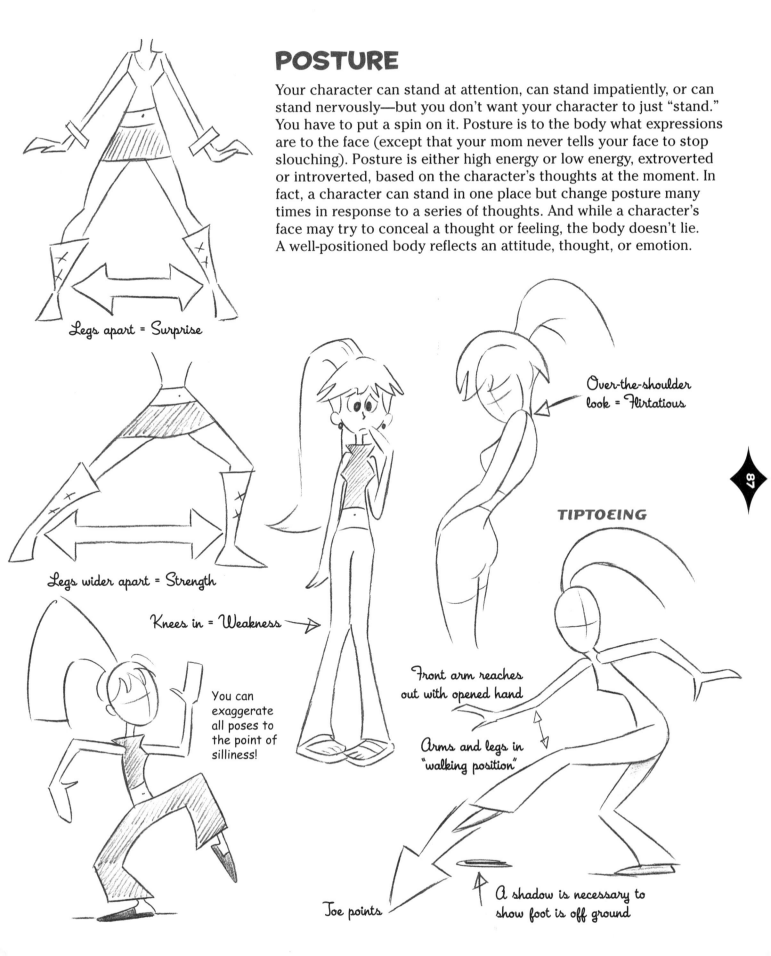

Legs apart = Surprise

Legs wider apart = Strength

Knees in = Weakness

You can exaggerate all poses to the point of silliness!

Over-the-shoulder look = Flirtatious

TIPTOEING

Front arm reaches out with opened hand

Arms and legs in "walking position"

Toe points

A shadow is necessary to show foot is off ground

BASIC TEENAGE STANDING POSTURE

Suppose that your character enters a room in which there's a discussion going on. She first has to listen to what's being said before she can react to it. This is when she'll assume a neutral pose, of which there are three basic types:

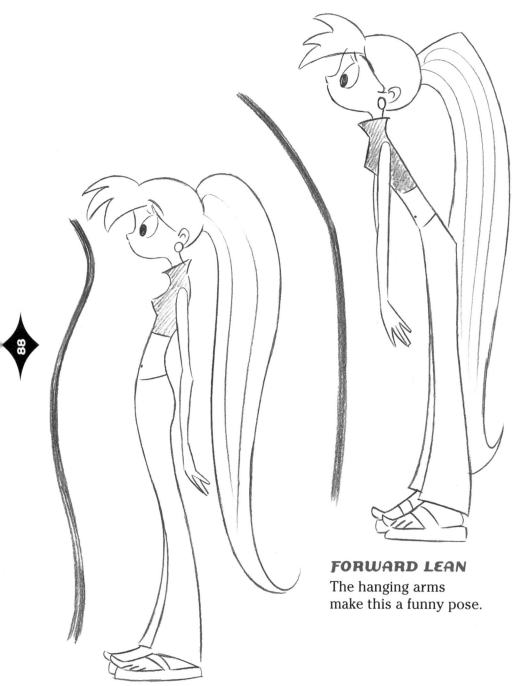

FORWARD LEAN
The hanging arms
make this a funny pose.

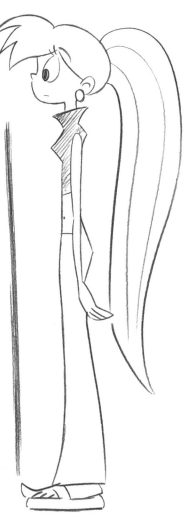

BACKWARD SLUMP
Note how the backward curve
of the legs adds to the nice
sweep of the pose.

RETRO NEUTRAL
This is very flat. No one
stands this way in reality.
All of us slump a little.

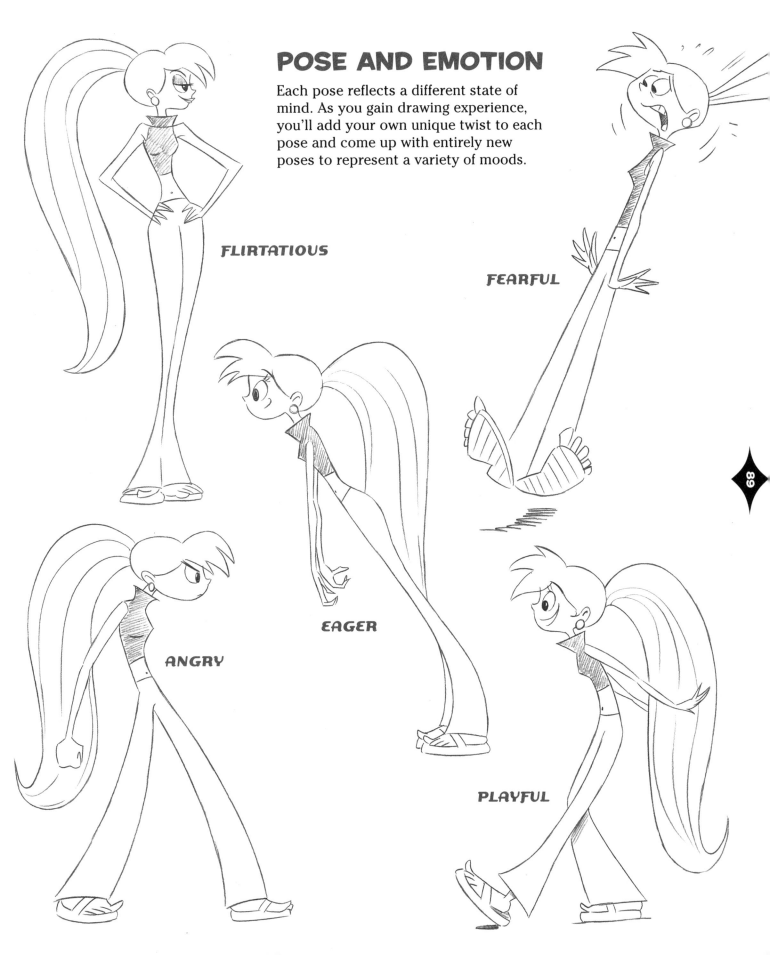

POSE AND EMOTION

Each pose reflects a different state of mind. As you gain drawing experience, you'll add your own unique twist to each pose and come up with entirely new poses to represent a variety of moods.

FLIRTATIOUS

FEARFUL

EAGER

ANGRY

PLAYFUL

PRETTY RETRO Women

Pretty women have a way of lighting up a scene. They make sharp, eye-catching characters that you want to see. But because they aren't broad and goofy, they can sometimes pose a problem for newer artists because of the difficulty in achieving the nuances necessary to make a character look attractive. Retro women, however, are easier to draw because there isn't a whole lot of nuance going on with this style, which is what makes it so much fun and so broadly appealing. Think of drawing pretty retro gals as going for ultraexaggerated femininity.

THE FACE

Big eyes and big lips are your one-two punch when drawing a female knockout. The eyes are elongated almond shapes, not circles or ovals. And they should be pointy at the ends. The upper eyelids must be dark and thick. Add eye shadow to further accent the eyes. Give her long, thick eyelashes at the ends of her eyes.

The lips come directly from Collagen Central. She needs to have a major-league overbite. When the bridge of the nose shows, use a single line from the eyebrow to the nose to create the bridge. Cover up most of the forehead with bangs, unless your character wears her hair back. Show her shoulders and a long neck whenever possible.

PRETTY GIRLS AND THE "EYE TILT"

It's absolutely essential to tilt the eyes in the right direction in order to make the character pretty.

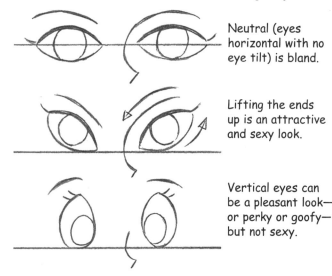

Neutral (eyes horizontal with no eye tilt) is bland.

Lifting the ends up is an attractive and sexy look.

Vertical eyes can be a pleasant look—or perky or goofy—but not sexy.

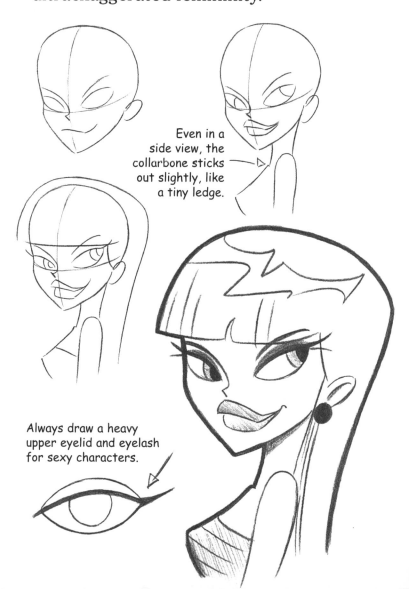

Even in a side view, the collarbone sticks out slightly, like a tiny ledge.

Always draw a heavy upper eyelid and eyelash for sexy characters.

THE HEAD TILT

Dip the chin slightly, and show the character looking up under heavy eyelashes for a seductive or alluring look. On pretty female characters, it's possible to get away without drawing the nose at all. In those cases, glamorous eyes become even more important. Note the detail in the eyeball.

91

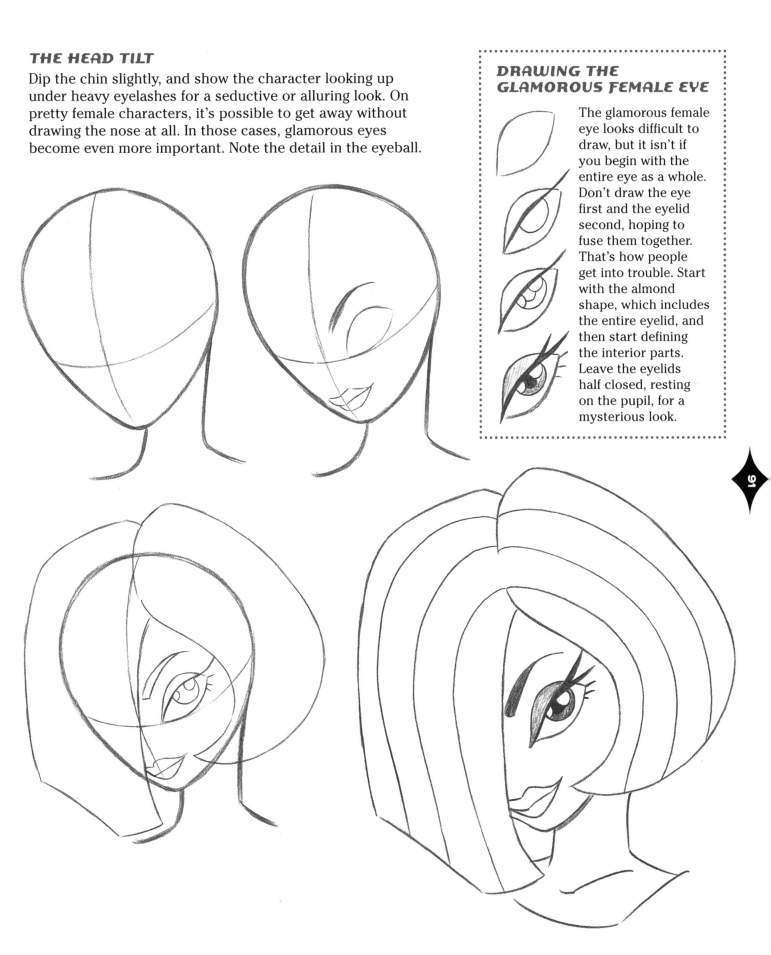

DRAWING THE GLAMOROUS FEMALE EYE

The glamorous female eye looks difficult to draw, but it isn't if you begin with the entire eye as a whole. Don't draw the eye first and the eyelid second, hoping to fuse them together. That's how people get into trouble. Start with the almond shape, which includes the entire eyelid, and then start defining the interior parts. Leave the eyelids half closed, resting on the pupil, for a mysterious look.

THE VOLUPTUOUS FEMALE FIGURE

These are the important things to note:

Long neck

Wide shoulders

Large rib cage

Narrow waist

Wide hips

Full thighs (wedged high into hips)

Tapered legs

Leg gets thinner at knee joint

Shapely, but not large, calf muscles

Leg gets thinner at ankle joint

Foot sweeps away from body in an attractive pose, led by the toes

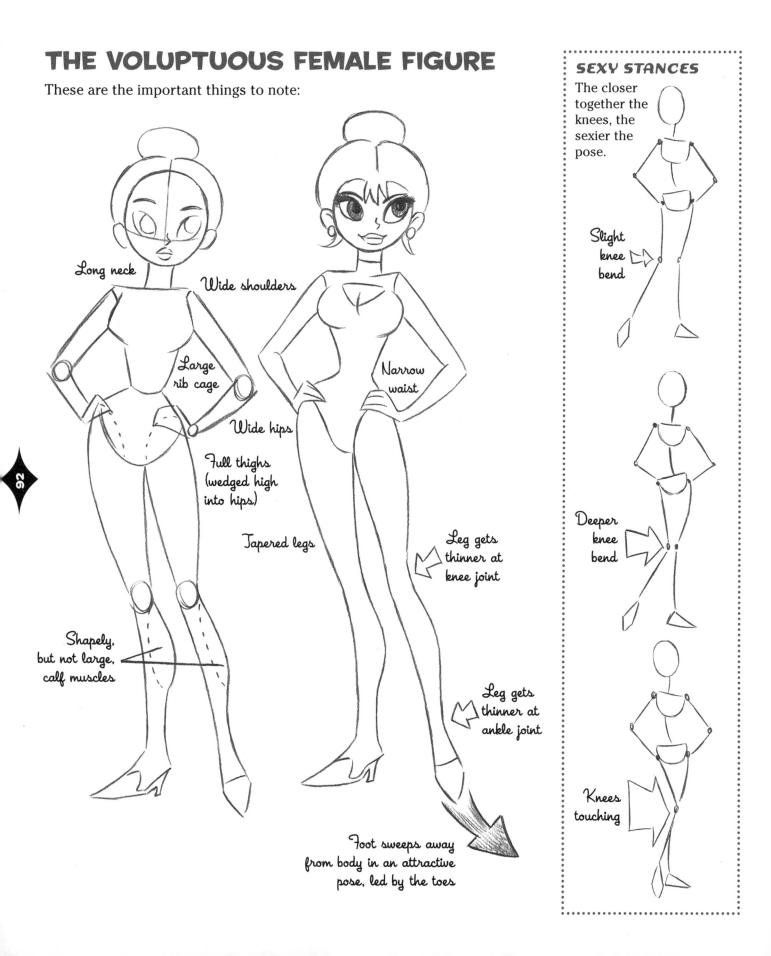

SEXY STANCES

The closer together the knees, the sexier the pose.

Slight knee bend

Deeper knee bend

Knees touching

MIDRIFFS AND LOW-CUT PANTS

This is a '60s hippie-chic look, with bell-bottoms and arm cuffs. The backward-leaning posture is a cool, slinky pose for thin (as opposed to voluptuous) characters. Note that the head remains straight up and down, even when the body leans back. It's a natural counterbalancing reaction; otherwise, the body would fall over every time a person leaned in a direction.

STYLIZED SHOULDERS

This is also a good example of an attractive female character with shoulders that curve upward, which is a sharp stylistic choice. Although we refer to them as "square *shoulders*," what we're really talking about is the shape of the *collarbone*.

Collarbone

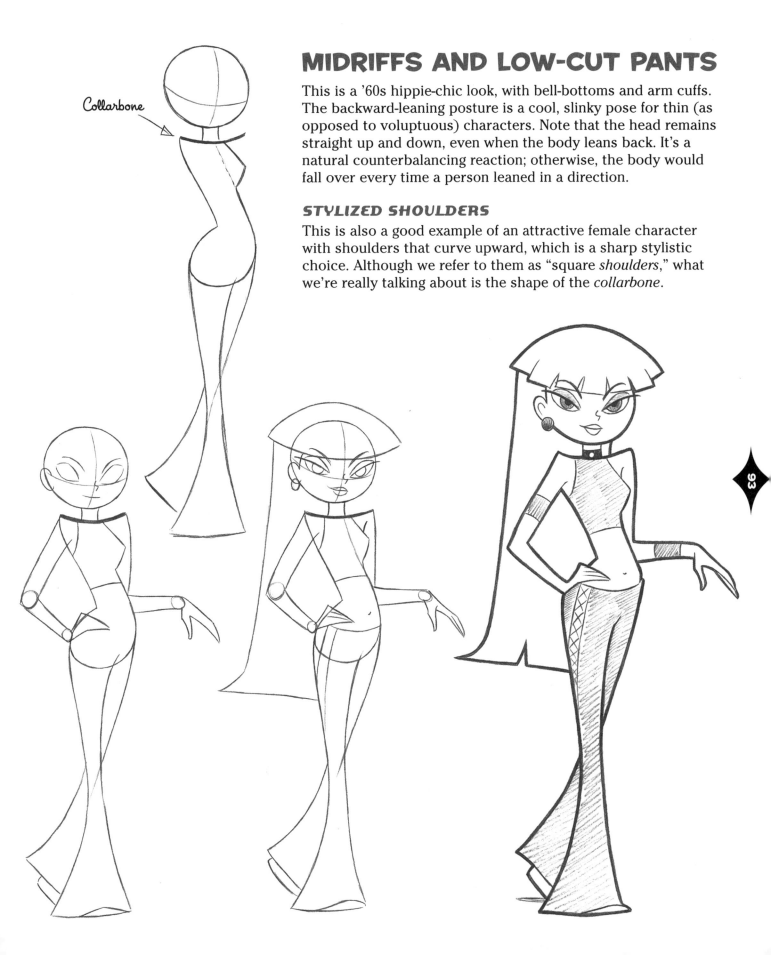

COOL CHICK

A pretty girl in sunglasses and a ragtop roadster—does it get any better than that? When you draw a cool chick, give her a blank expression, as if she were a model posing for a magazine cover. Hey, you can draw her with a big, toothy smile if you want, but then she'll look more like the girl next door, not like the heartbreaker she is.

Even though the wind is blowing, her hair maintains its forward-facing "do."

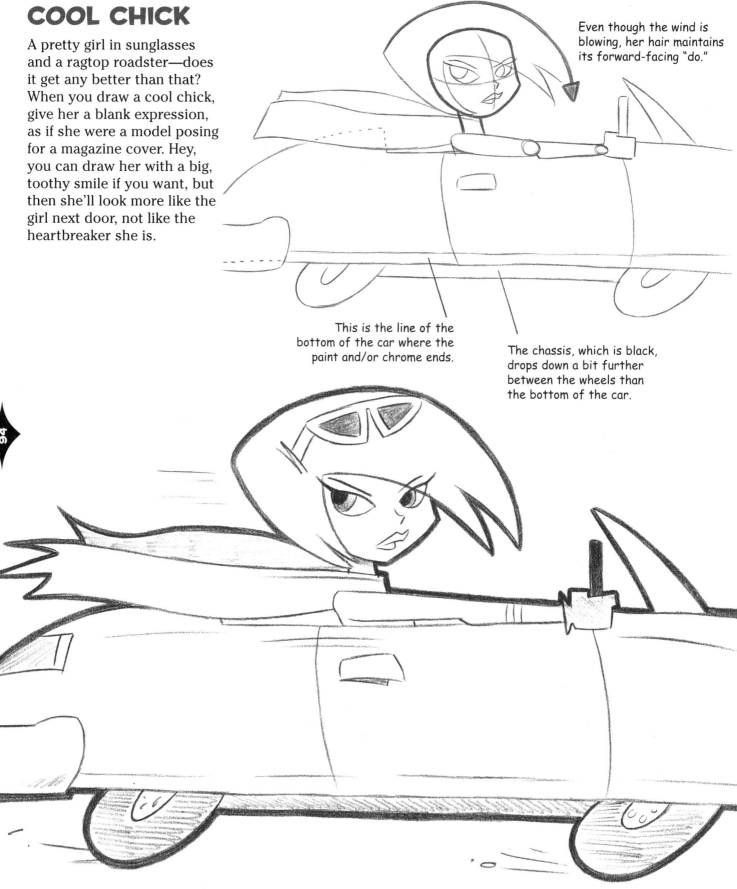

This is the line of the bottom of the car where the paint and/or chrome ends.

The chassis, which is black, drops down a bit further between the wheels than the bottom of the car.

CAN'T BUY ME LOVE

It's amazing the kind of a wardrobe you can put together for only $12,000 if you're resourceful enough. And for drawing fashion-plate cartoon females, here's the rule: the richer they are, the thinner they are. Although we like to make fun of fat rich people, it's the thin rich people that we despise. And that's because they make wealth look so good. That haircut alone costs enough to feed a Third World village for a week. You don't have to draw her dripping with diamond rings and necklaces to make the point; a simple set of oversized earrings does the trick. Garish isn't attractive. Think Italian designers. And, fashionable Euro-clothing doesn't have to fit snugly to have style. It can swim on her, and she still looks fabulously chic.

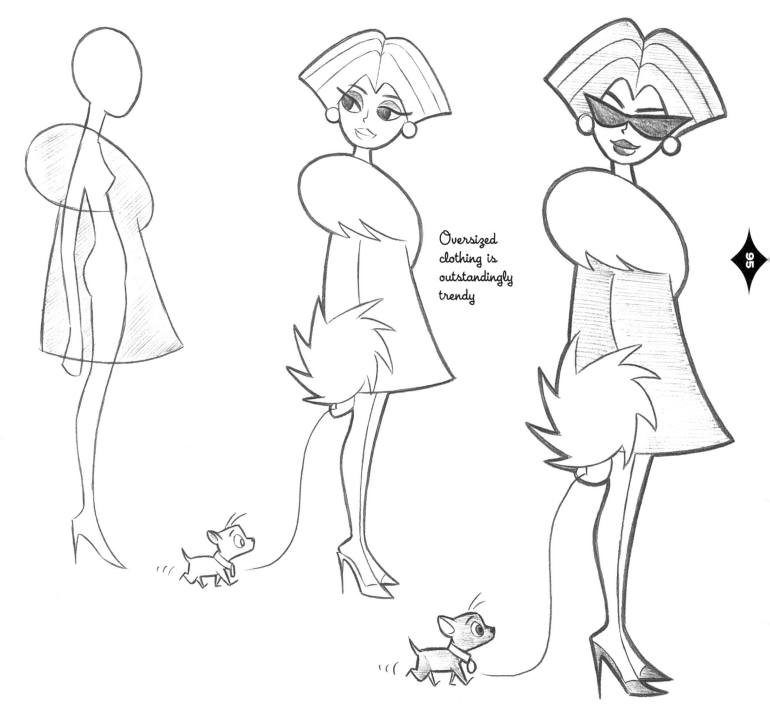

Oversized clothing is outstandingly trendy

NOTES ON DRAWING ATTRACTIVE POSES

Here are a few insights that took me years of pain and thousands of crumpled drawings to learn.

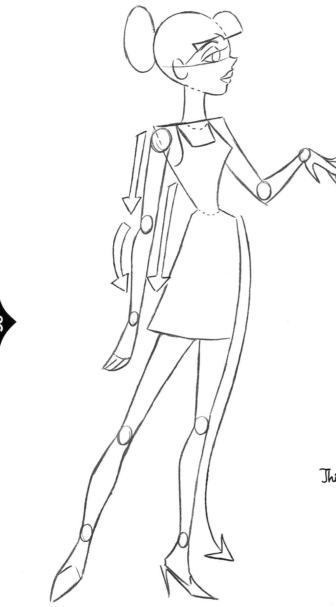

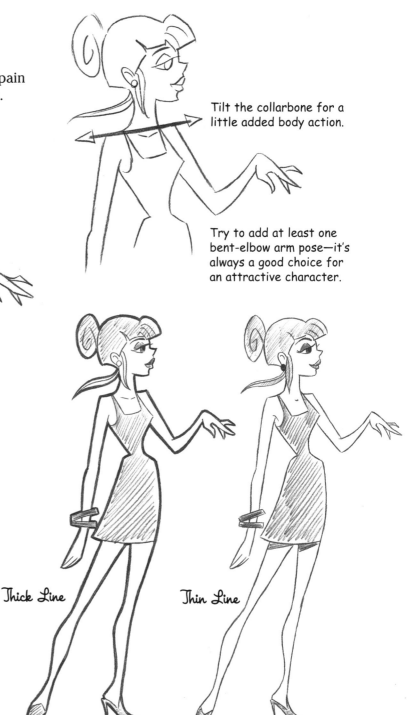

Tilt the collarbone for a little added body action.

Try to add at least one bent-elbow arm pose—it's always a good choice for an attractive character.

Thick Line

Thin Line

Avoid making the arms appear muscular or even athletic. Remember, this type of character goes to a spa for a facial, not a workout. Therefore, draw the interior line of the arm as a straight line. Draw another straight line for the exterior line of the upper arm, and draw a rounded line for the exterior line of the forearm. Also create one long sweeping line from the top of the hips to the tip of the shoe.

THICK LINE VS. THIN LINE

As mentioned at the start of the book, the retro cartooning style and thick pencil lines go together like HMOs and the refusal to reimburse. However, when you're drawing attractive characters whose sex appeal is front and center, it works equally well to use a thin line. It's true that a thick line will flatten out the character, giving it more of a retro look, but a thin line will make the character look a touch more feminine.

PRIMITIVE BEAUTY

If you don't have a few grand to spend on a blouse, you could always travel to an uncharted tropical island and find a great deal on summer outfits. There, you'll find stunningly beautiful cartoon characters wearing handmade clothes. Primitive beauties are always drawn with curvaceous figures and full thighs on tapering legs. The clothes are always formfitting and skimpy. There are always large earrings, stacked neck rings, animal skin clothes with stitching, fur-lined boots, and bracelets. Shoulder and thigh bands complete the look.

Thigh bracelets are attractive

COOL RETRO Scenes

Now it's time to take everything we've covered, put it all together, and create cool scenes with multiple characters. All the same principles still apply, but now we're creating scenes based on concepts. As a result, the characters will be more focused. If it sounds harder, it isn't. You'll have fun with it. It's what retro is all about: creating scenes where the sparks can fly. So keep everything simple, bold, and flat.

NO, YOU GO FIRST

Would you enter a cave like that? Me neither. But they will. They're cartoon characters. And this is what they do, darn it.

Both characters exhibit the same body language: leaning back in fear. They are both looking at the cave's interior. Note that you don't need a whole lot of props to create a spooky environment. No cobwebs, no spiders or half-buried skulls in the ground. Just one good, demonic lamp does the trick. Of course, it helps that this is a nighttime scene, with a full moon. Also, the craggy tree in the background with its dead, black trunk is an ominous sign—and a necessary one, otherwise the forest would look too pristine and pastoral.

PENCIL VERSION

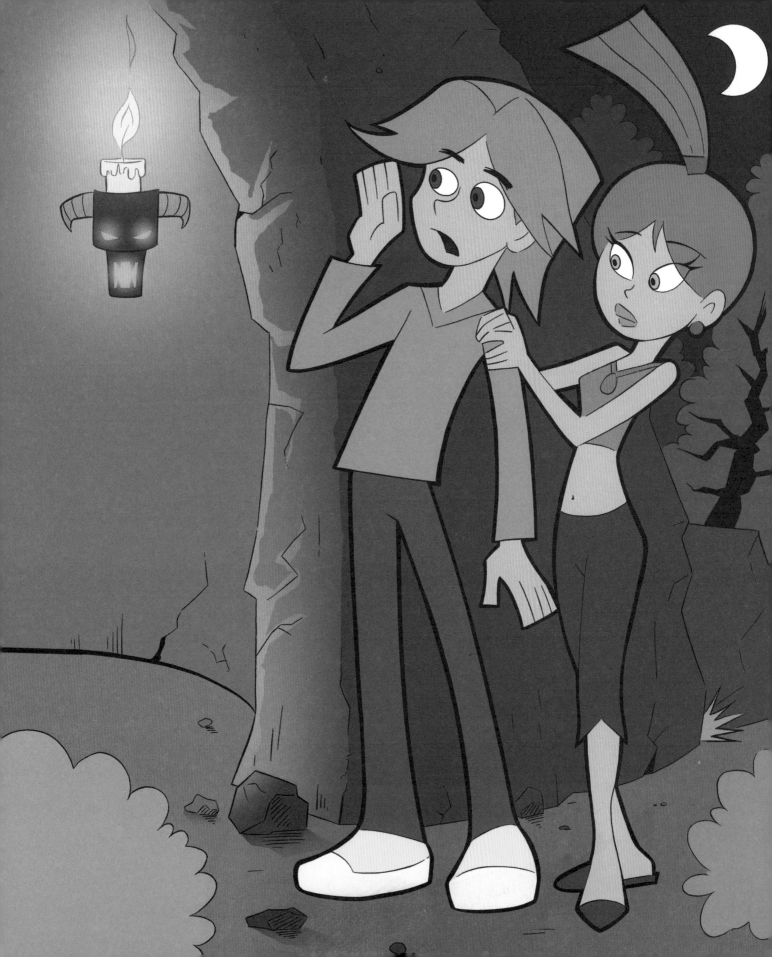

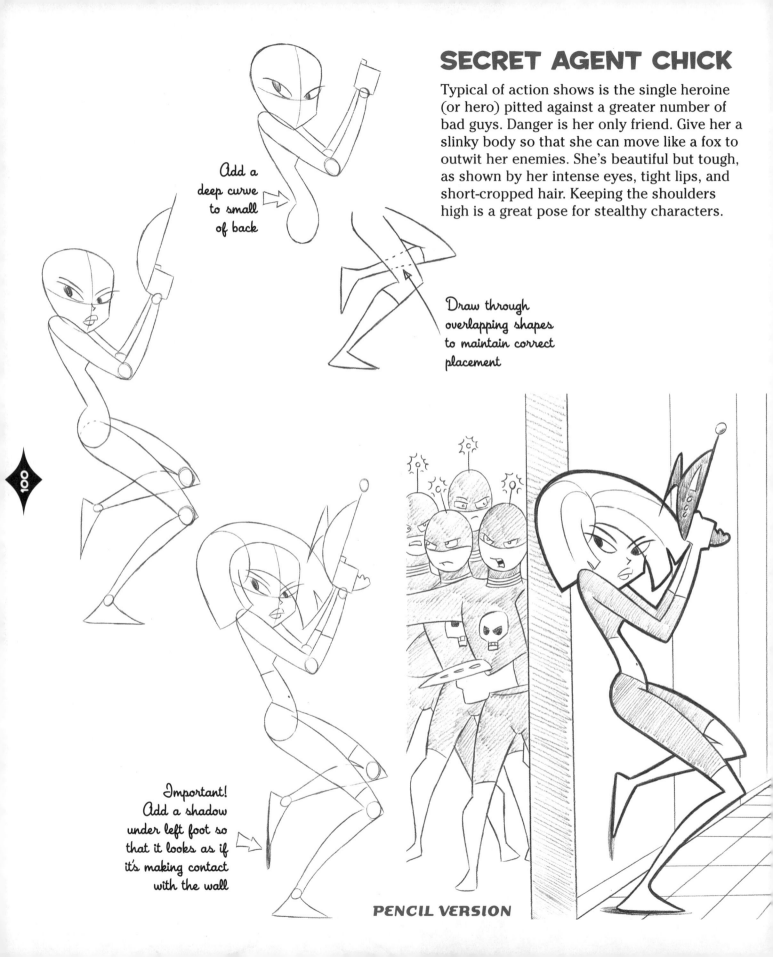

SECRET AGENT CHICK

Typical of action shows is the single heroine (or hero) pitted against a greater number of bad guys. Danger is her only friend. Give her a slinky body so that she can move like a fox to outwit her enemies. She's beautiful but tough, as shown by her intense eyes, tight lips, and short-cropped hair. Keeping the shoulders high is a great pose for stealthy characters.

Add a deep curve to small of back

Draw through overlapping shapes to maintain correct placement

Important! Add a shadow under left foot so that it looks as if it's making contact with the wall

PENCIL VERSION

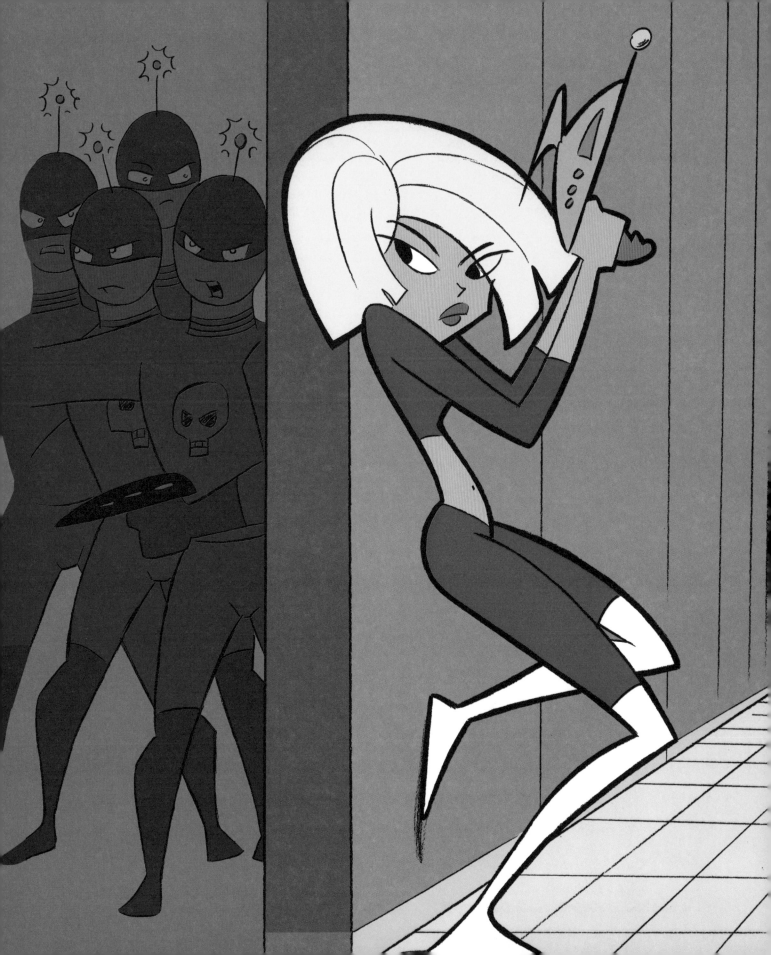

GALACTIC MEDAL OF VALOR

This one's for killing the giant-cockroach-mutant-invaders from planet Zonk. I think. These two burly characters are about the same height, and both have jutting jaws. So, it becomes important to create noticeable differences in costume and hairstyle. I've also given the pilot on the left extra-long arms, while the commander on the right gets shorter ones. And here's a note about character design for you to file away: on a character with a big manly jaw, the nose should be small so as not to compete with the rest of the face.

Now take another look at these space characters. They're standing in profile. A profile requires that you show the curves of the spine as it travels from the head (remember, the neck is part of the spine) to the feet.

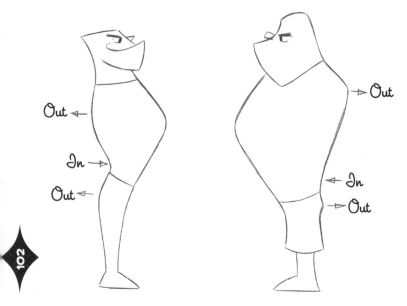

Out ←
In →
Out ←

→ Out

← In
→ Out

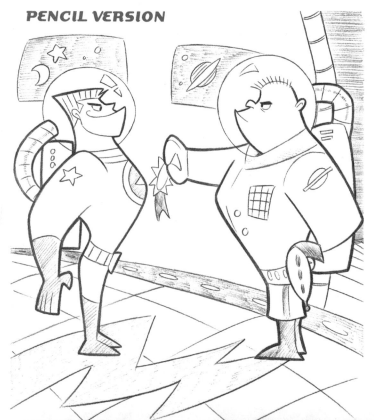

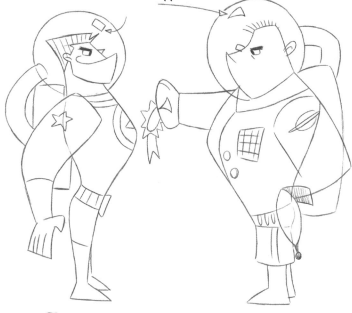

Add a shine to the glass to make it appear solid

To add humor, give both characters flat feet

PENCIL VERSION

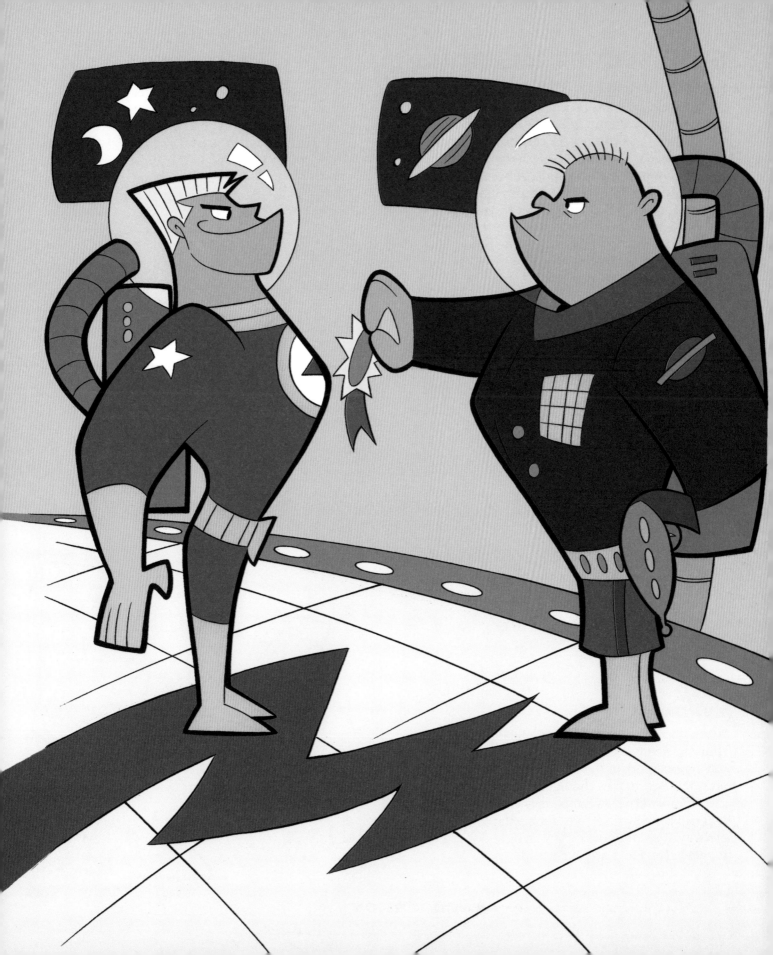

SHH! SECRET MISSION

Pardon me if I whisper—I don't want to foul them up and risk the survival of the free world. So, here we are, deep in the belly of a supervillain's underground laboratory. Notice how the characters walk: gingerly, so as not to alert any guards. In this way, you create a relationship between what the characters are doing and the environment they're in.

When drawing two characters walking in single file, make sure that their feet are on the same level, that one figure isn't higher than the other. This helps create the illusion that they're really walking on solid ground.

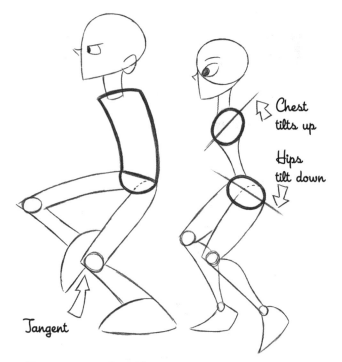

Chest tilts up

Hips tilt down

Tangent

To create comfortable standing or walking postures, tilt the chest and hips in opposite directions.

Contrast rounded heads with flat heads for added interest

TANGENTS

Normally, in animation and comics (but especially in animation), you avoid having one part of the body touching another, as it makes the figure look flat. The spot where this happens is called a *tangent*. But since retro is such a flat look anyway, it's not necessary to avoid tangent. Tangents are our friends.

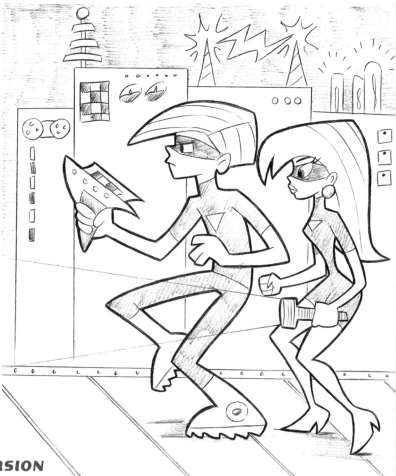

PENCIL VERSION

104

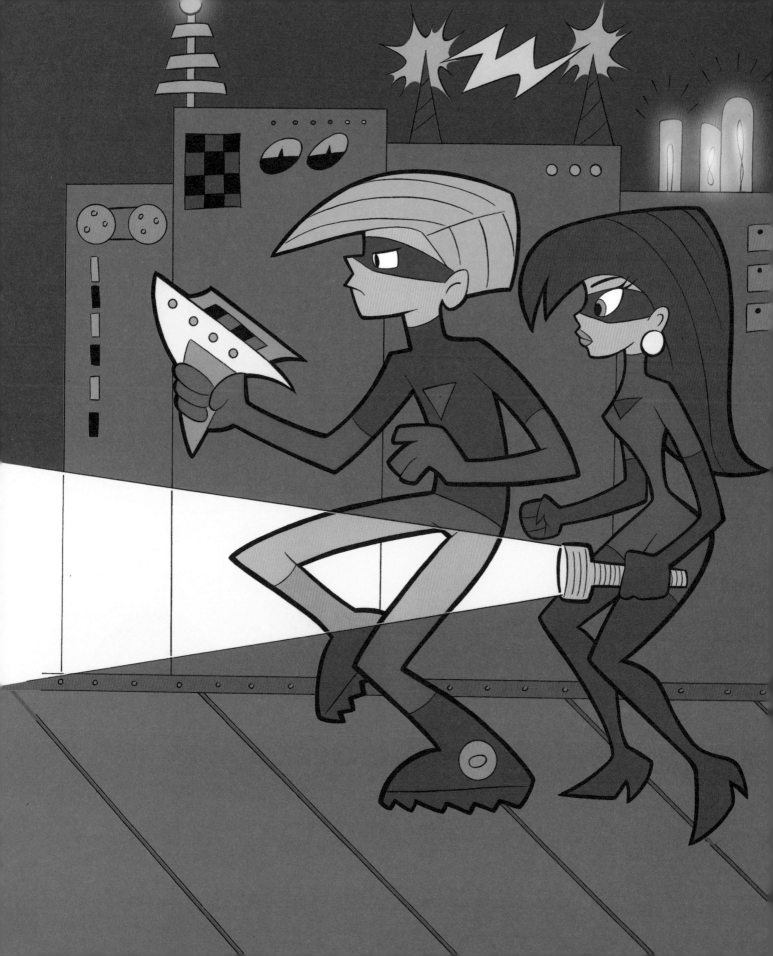

JEWEL THIEF

What's silly about this picture? Look closely. It's her necklace and earrings. What thief wears a pearl necklace and earrings to a burglary? But it's funny, and it adds glamour. It's good to find ways to add humor and glamour to your jewel thief scenes.

For a crouching pose, the heels tuck directly under her bottom, not beyond it. Her arms are outstretched in opposite directions to provide balance. Her eyes dart to the sides, ever wary of danger. Long boots and action-figure-style gloves always provide a good look and can be quite stylish, too. And, like all master jewel thieves, she wears all black.

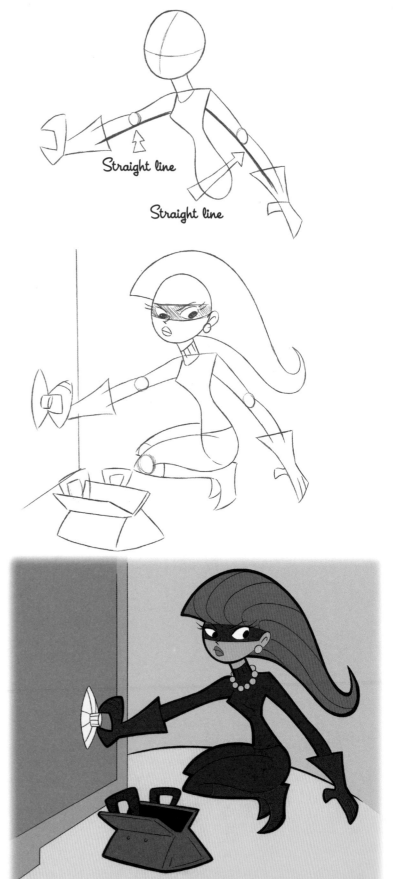

Straight line

Straight line

Note the curving line of the thigh, which goes deep into the knee joint when the legs are compressed against themselves.

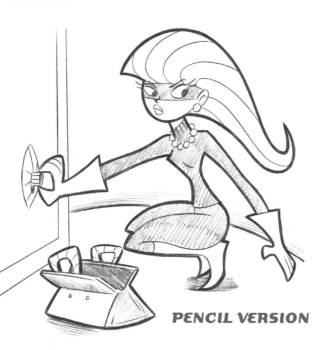

PENCIL VERSION

MY HERO!

I hate to tell him this, but the fire is in the *other* building. To draw a character scaling a wall or building, turn the drawing paper so that the figure appears to be upright. Then draw the figure in a walking stance with knees deeply bent, lean the body back, and raise the arms and shoulders up so that they cover part of the chin. Now turn the paper back to where it was. That's all there is to it!

Put a cloud in the sky to make it seem like he's way up in the air. Draw it long, vertical, and thin so that it will look right when you rotate the final drawing.

The rope should vary in thickness to look as if it is being stretched to the limit.

Raise the tip of the front foot.

Her hands must be placed on the outside of the building, to give the scene a sense of urgency.

PENCIL VERSION

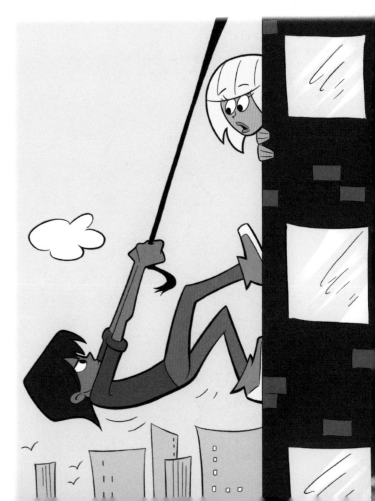

HERE MONSTER, MONSTER

He's brave. He's determined. He's completely clueless. Not all heroes are bright. Some are just persistent.

Retro evil monsters should be big and should tower over their victims. But they should also be goofy. Keep the style consistent, even for bad guys. Maybe you can draw a seriously scary creature, but that's not the feeling of this scene or of the retro style in general, which is one of humor—even in action comics. Also, be sure to style the guns so that they don't look dangerous. They should look like turbo-charged water pistols.

And, take a look at the background in this illustration. I love a good retro rocket ship poised to take off from the planet surface. It's the "pink flamingo" of science fiction.

PENCIL VERSION

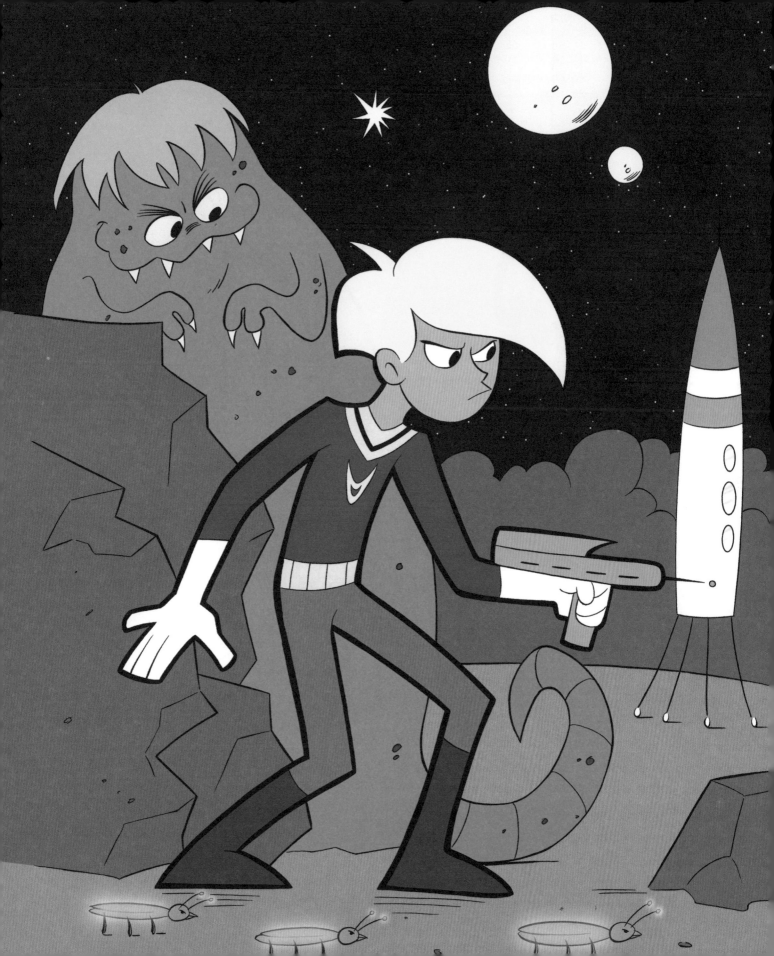

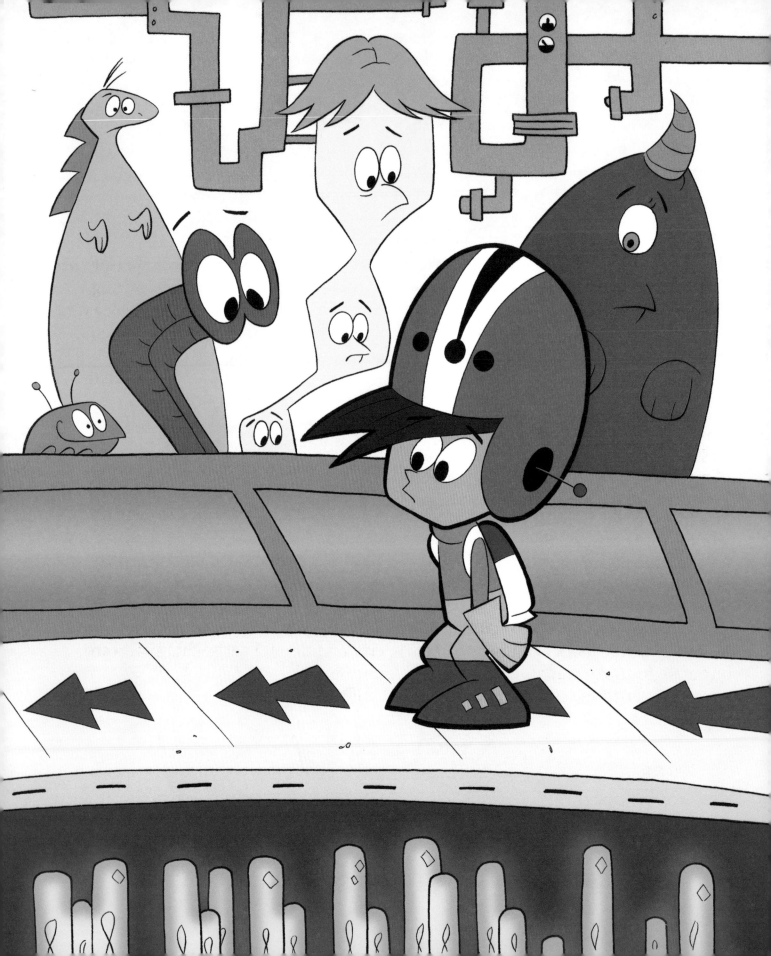

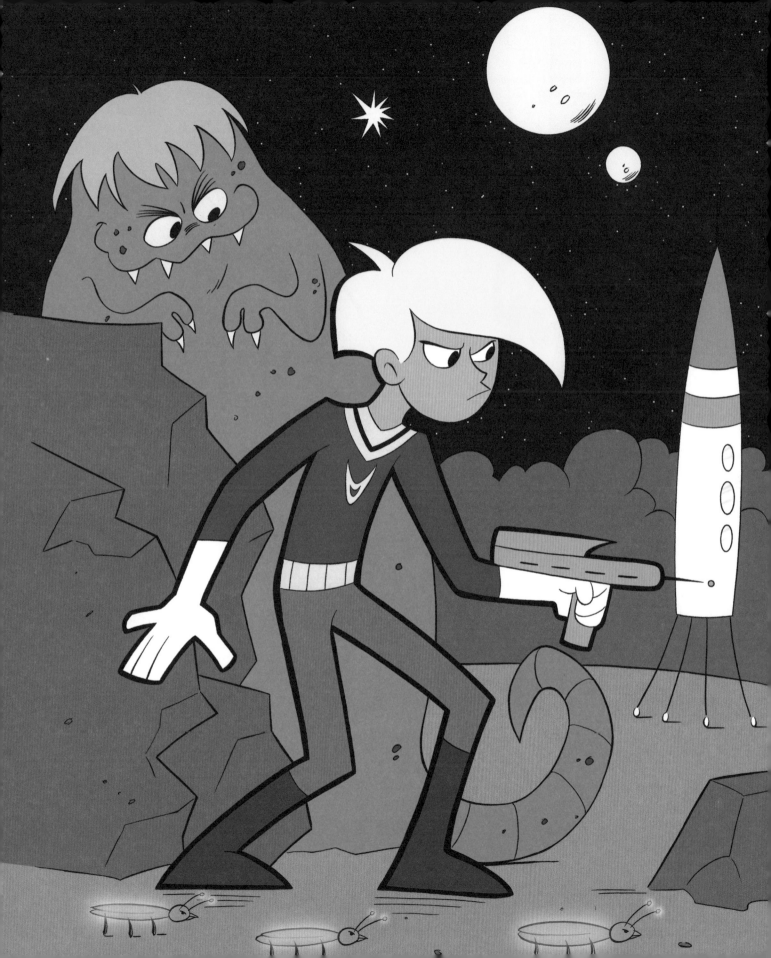

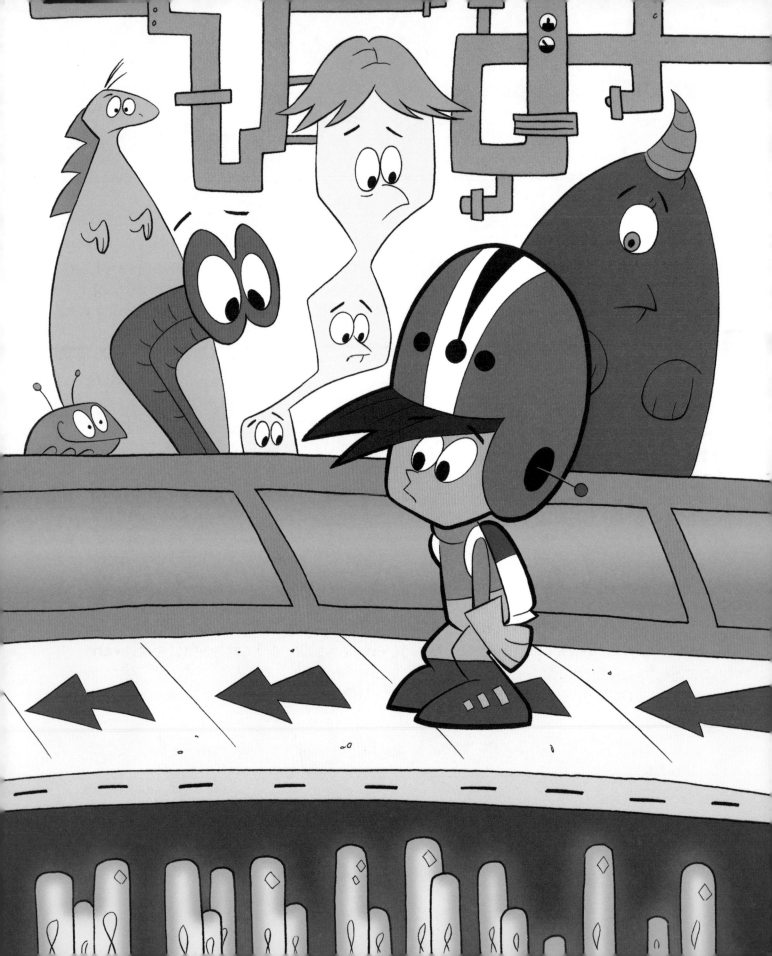

Well, here we are at the end of this book (unless you're reading it in Hebrew, in which case, "Welcome!"). It has been delightful keeping you company and watching your creative juices work overtime. There are three essential ingredients necessary to becoming a good cartoonist: practice, technique, and a bag of chips. Two, if you leave out the practice. Some people just practice and never improve because they, unlike you, don't bother to get more information on cartooning techniques. Some people get the info but don't practice. And some people never buy a decent bag of chips, opting instead for pretzels or pork rinds.

Don't feel as if you have to go through this book like a class assignment, with your nose to the grindstone until you can draw everything in here perfectly.

When I was first starting out, I got loads of books on drawing, looked through them all, and created a mini library for myself. Then I began to draw. When I got stuck, I reached for one of my books to remind me of the principles I had learned or to give myself a bit of encouragement or inspiration. I believe that's the best way to do it: Get all of the info you need. Enjoy it. Let yourself digest it in your subconscious, where it will evolve and come out later in one of your drawings as a burst of inspiration. Your creative mind is working even when you're not practicing. It really is. Trust that process. Try to learn new things. But then just forget about everything else and draw. That's what you were born to do.

Until next time!